In Praise of Women

Jonathan Meader

In Praise of
WOMEN

Edited by **JONATHAN MEADER**

Foreword by **Isabel Allende**

CELESTIALARTS
Berkeley, California

Celestial Arts
P.O. Box 7123
Berkeley, California 94707

Distributed in Canada by Publishers Group West, in the United Kingdom and Europe by
Airlift Books, in New Zealand by Tandem Press, in Southeast Asia by Berkeley Books, and in
South Africa by Real Books.

Cover design by Star Type
Interior design by Riba Taylor and Jonathan Meader

Library of Congress Cataloging-in-Publication Data

In praise of women / edited by Jonathan Meader.
 p. cm.
 Includes bibliographical references and index.
 ISBN 0-89087-842-0 (pbk.)
 1. Women in art. 2. Goddesses in art. 3. Sculpture.
 4. Figurines. 5. Women—Quotations, maxims, etc. I. Meader.
 Jonathan.
 NB1939.I5 1997
 731'.8244—dc21 97-26260
 CIP

First printing, 1997
Printed in Singapore

1 2 3 4 5 6 - 00 99 98 97

For my beautiful daughter Hope

Contents

Foreword

What is it to be a woman? For an instant, close your eyes. Dream. You enter a vast white vault—the pages of this book—and as you walk slowly, as if in a trance, the way one moves in dreams, amazing feminine figures greet you. Some of them you may have seen before, but here they stand under a magic light. They are alive. One after another, in no apparent order and yet perfectly organized according to a subtle logic, these noble creatures of clay, wood, and stone reveal themselves to you in their timeless beauty and strength. Of each one you ask the same question: What is it to be a woman? And each one answers in her own powerful voice:

> *I am the goddess of fertility and the idol of temptation, mother and whore.*
>
> *I am the womb where life begins and the breasts that nurture.*
>
> *I am the arms that embrace you in love and hold you in death.*
>
> *I am the eyes that see the soul and shed the tears of compassion.*
>
> *I am the hands that plow, and weave, and rock the child.*
>
> *I am the seer and the healer, but also the witch and the avenger. Beware my anger.*
>
> *I am the virgin and the crone, desired and feared, sought and destroyed, always blamed.*
>
> *I am woman, mysterious and eternal.*

I turned the pages of this book with gratitude because it is not often that an homage like this comes from a man. In these confusing times, when women are redefining themselves and many men feel threatened by their unleashed power, this book comes as a rare gift from a man to all women and men. Jonathan Meader doesn't try to explain the feminine or decipher its contradictions: he simply stands in admiration of women. With great sensitivity, he has selected sculptures that transcend time and aesthetic rules, and matched them with poignant quotes and historical notes. Every image is an invitation to explore different aspects of an infinite subject. His own voice is nearly absent in these pages, and his discreet silence allows the beholder to dwell freely in the secret nature of each sculpture without judgment. As a woman I find this book deeply moving. Thank you, Jonathan, for your unique way of praising us.

Isabel Allende

Next to God, we are indebted to women,
first for life itself,
* and then for making it worth having.*

C. NESTELL BOVEE

Art is the lie that enables us to realize the truth.

PABLO PICASSO

WOMAN'S PORTRAIT

Carved from mammoth ivory 27,000 years ago, this sensitively done head was found in France in a cave that was inhabited by early man during the Late Paleolithic (Old Stone) Age. Successors of Neanderthals, they lived during a warming period between two intensely cold phases of the last Ice Age. Lands to the north lay buried under mountains of ice, smothering parts of Europe with sheets more than a mile thick.

Evidence suggests these people lived peacefully, successfully adapting to their environment, communicating, cooperating, trading goods over great distances, and creating works such as this one, which shows a strong aesthetic sense.

. France; 25,000 BC; mammoth ivory; height 1.5 inches (3.8 cm).

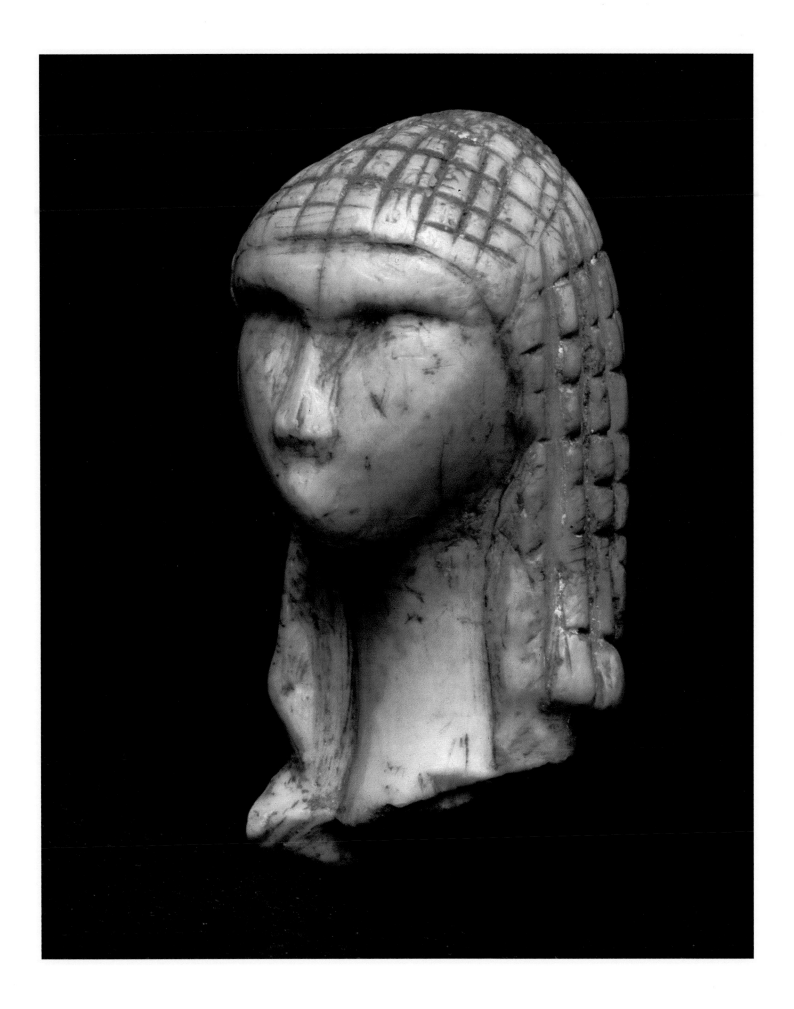

*The aim of art is to represent
not the outward appearance of things,
but their inward significance.*

ARISTOTLE

VENUS OF WILLENDORF

Discovered deep in a cave in Austria, this voluptuous woman was carved out of limestone 23,000 years ago. Her head is modestly tilted forward, hair carefully arranged, slender arms not accustomed to heavy labor; she seems not only to have been cared for, but cherished. Perhaps her people knew that well-nourished mothers produced the healthiest babies, a community's best hope for survival. She lay in darkness while the stars crossed the night sky eight million times, until at last, a hundred years ago, she once again warmed in someone's hand.

. Austria; 24,000 BC; limestone; height 4.4 inches (11 cm).

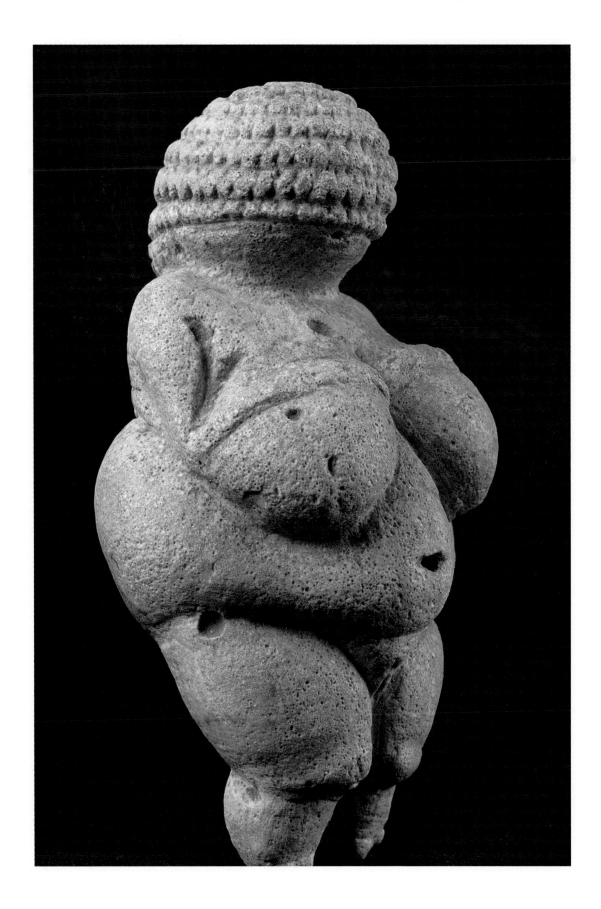

Out of the window
I saw how the planets gathered
Like the leaves themselves
Turning in the wind.

WALLACE STEVENS

ENTHRONED GODDESS

This sculpture is a wonderful harmony of rounded shapes. The goddess is giving birth, her baby's head just appearing between her ankles. Powerful and proud, this woman seems the very essence of creation, yet her posture suggests a certain detachment, perhaps indicating that she is also witness to the endless turning of the universe. Made of baked clay, she was discovered in the ruins of Çatal Hüyük, an Anatolian settlement which flourished 8,000 years ago in what is now central Turkey. More than 1,000 homes were constructed there, packed together without passageways between, and with entrances in the flat roofs. The people farmed, irrigated their fields, raised cattle, controlled a vast trading network, and seem to have lived in peace for a thousand years. Over forty elaborate shrines (approximately one for every four homes) have been uncovered, many organized around similar goddess figurines.

. Çatal Hüyük, Anatolia (Turkey); 6000 BC; fired clay;
height approx. 6 inches (15.25 cm).

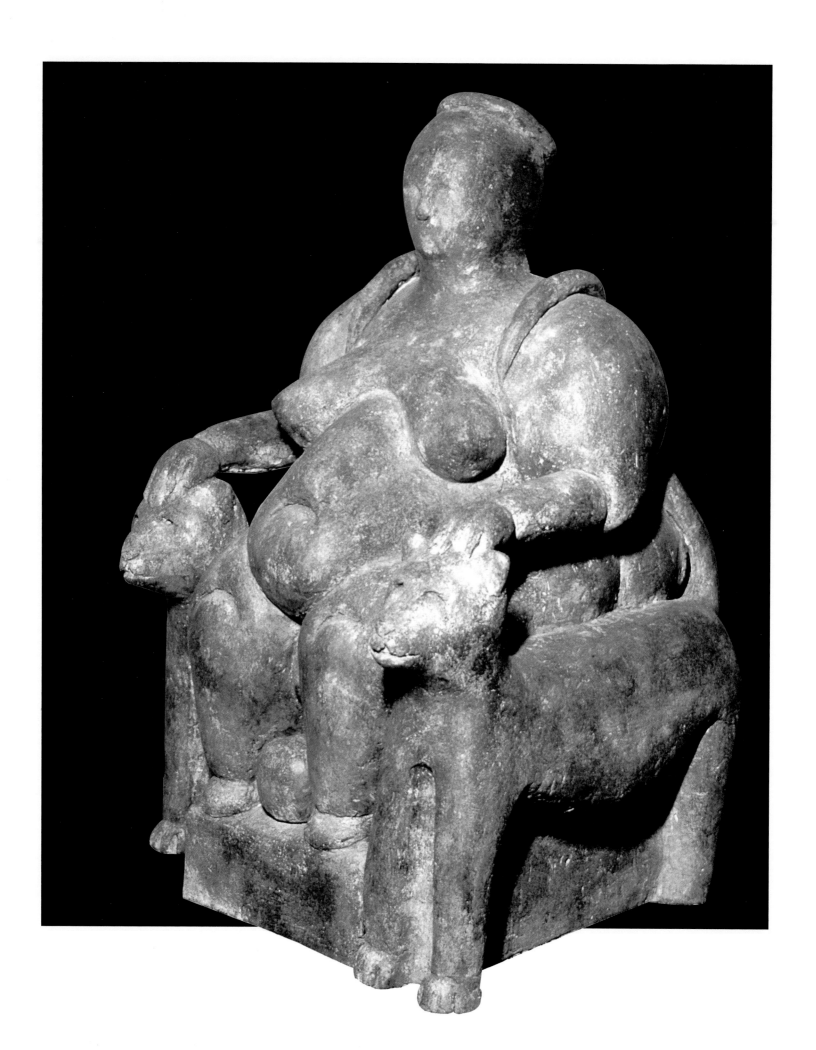

If eyes were made for seeing,
Then Beauty is its own excuse for being.

RALPH WALDO EMERSON

BIRD GODDESS

This sensual figurine comes from the Lengyel culture, which in the fifth millennium BC spread throughout much of what is now Yugoslavia, Austria, and Poland. They built communities by lakes, rivers, and streams in level protected areas, constructing longhouses out of timber, wattle, and clay. Rich soil permitted year-round farming, and they also raised pigs, cattle, sheep, and goats. Brightly painted pottery in reds, yellows, and black, and a large number (over 100 in one site alone) of these highly original sculptures have been unearthed.

. Czech Republic; 4900 BC; baked clay; height 8.5 inches (21.5 cm).

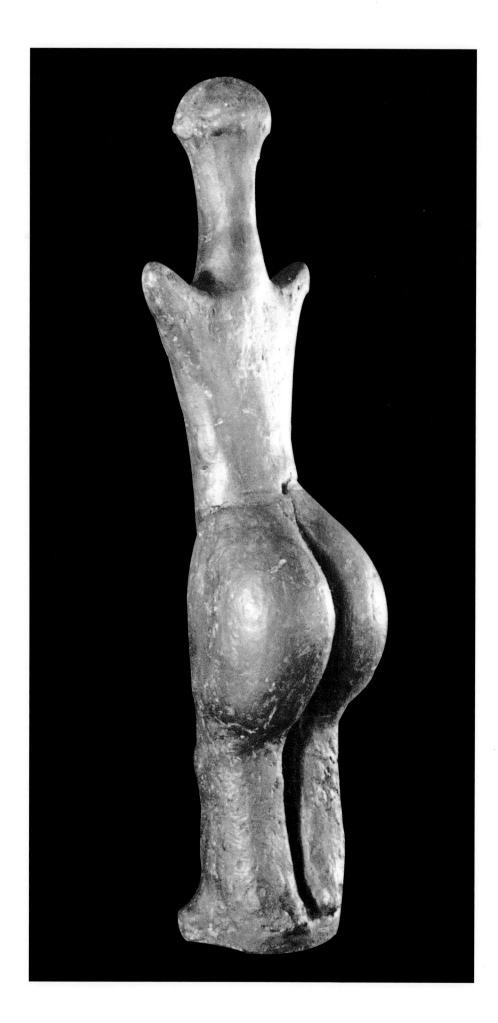

True art lies in a reality that is felt.

ODILON REDON

CUCUTENI FIGURINE

The Cucuteni culture, coexisting with the Lengyel, lay to the east of them in what is now Romania. They were one of the richest cultures of old Europe, enduring for a thousand years. Like the Lengyel, they built their villages near rivers where they fished, cultivated the rich black soil, and grazed their animals. Single communities sometimes grew to 2,000 homes, and covered 500 acres. Longhouses were the most common structures, but there were also two-story dwellings with pitched roofs. Ruins of workshops with huge ovens and dozens of beautifully decorated bowls have been discovered. The Cucuteni produced excellent ceramics. The inscribed lines on this exquisite figurine were originally filled with white paste.

. Romania; 4400 BC; baked clay; height 3.3 inches (8.5 cm).

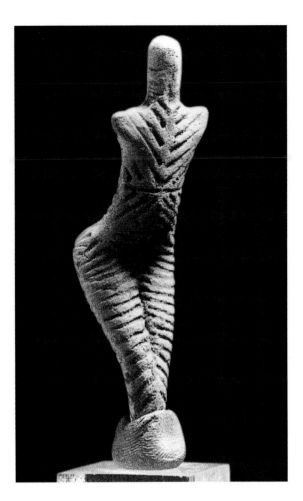
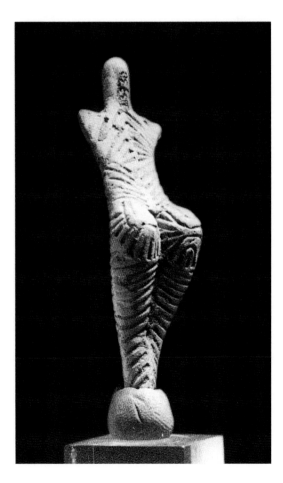

*W*e could never learn to be brave and patient,
if there were only joy in the world.

HELEN KELLER

CYCLADIC GODDESS

The Cyclades are a loose cluster of twenty-seven islands in the Aegean, southeast of Athens. Most of what we know about the ancient inhabitants comes from their Early Bronze Age burial sites, for little else remains. Around 3200 BC the islanders began placing white marble figures in their graves. Of the limited variety of shapes they produced, the most common were of the type shown: a stylized woman, arms folded over her stomach, legs together, face smooth except for a nose (other features were sometimes painted on), and knees bent with toes slightly pointed, to indicate she is lying down. The deceased were placed in their graves in a fetal position, as if waiting to be born into the next world, with one of these goddess figurines lying beside them.

. Cyclades Islands, Greece; 2700–2300 BC; marble; height 6.9 inches (17.5 cm).

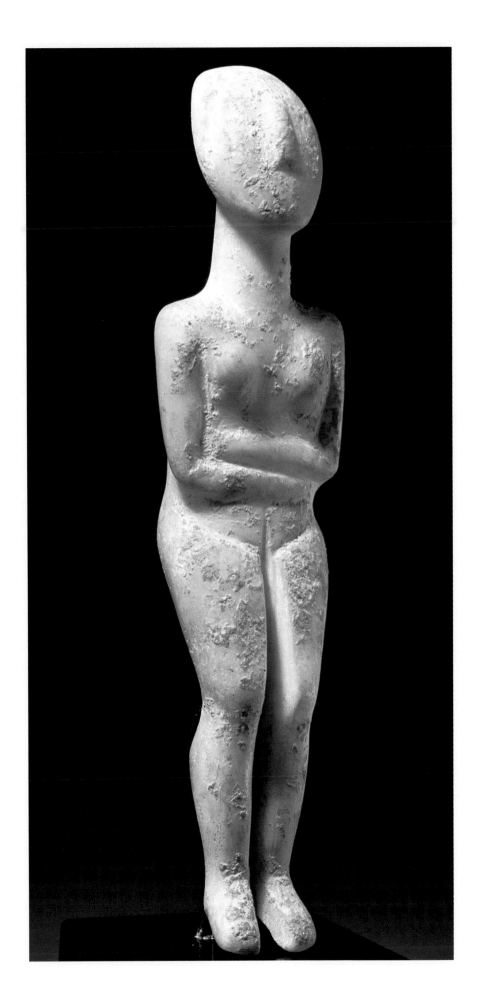

*When I was young I told
everyone I had a twin sister.
One day, after we had been to
see the relatives, my mother
told me I was too old to play
that game any more. So I
stopped talking about her &
after awhile, she finally
went away.
But I'm grown up now & I
still miss her & I wish she
would come back.*

BRIAN ANDREAS

CYCLADIC SPIRIT

Cycladic marble figures, carved during the Bronze Age 4,500 years ago, look remarkably modern and are sought by museums around the world. Though they are usually found in graves, it is suspected that they may have had other uses as well, because worn, repaired figurines have been recovered. Lacking glue, the islanders repaired broken figures by drilling holes in the pieces and lacing them back together. They traded their handicrafts with people from nearby islands for obsidian, bronze, lead, and silver. The sea may also have brought pirates, because in the third millennium BC the islanders began building walls around their towns. This double figurine is, to date, unique, and its significance is unknown.

. Naxos, Cyclades, Greece; 2800–2600 BC; height 18.33 inches (46.6 cm).

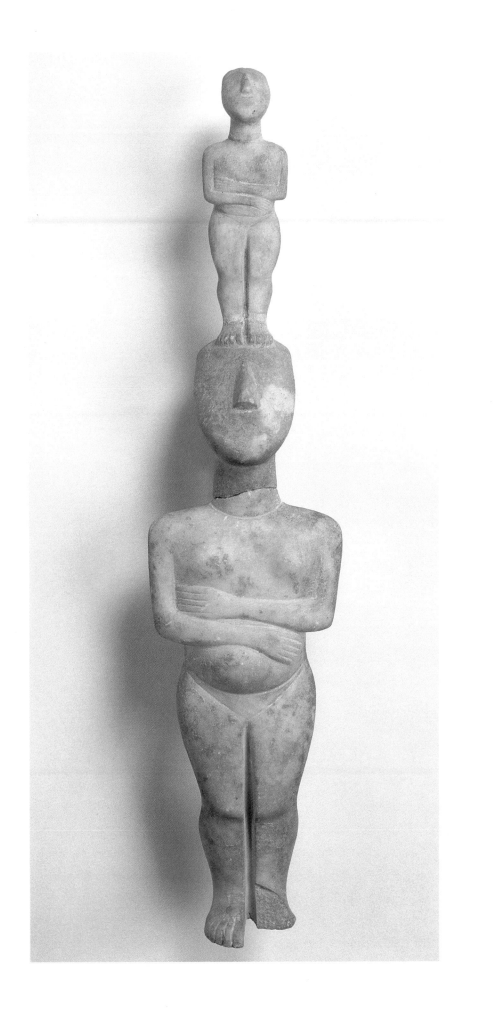

Grand go the Years—in the Crescent—above them
Worlds scoop their Arcs—
And Firmaments—row—
Diadems—drop—and Doges—surrender—
Soundless as dots—on a Disc of Snow—

EMILY DICKINSON

HITTITE ASTARTE

Astarte was the name given this goddess by the Greeks, who saw her as the Fertile Crescent (Middle Eastern) equivalent of Aphrodite. Except for a few Biblical references, little was known about the Hittites until 1905, when a German archaeologist digging in Turkey found thousands of their clay tablets. We now know they came from north of the Black Sea about 2000 BC, spoke an Indo-European language, and were fierce warriors but compassionate victors, respectful of the peoples they con-quered. The world's first known peace treaty—carved in stone—ended a war between the Egyptians and the Hittites; a copy hangs in the United Nations headquarters. Archaeologists speculate that figurines such as this one may have been given birdlike features to enable them to fly closer to heaven.

. Hittite; Syria; circa 1750 BC; fired clay; height 4.5 inches (11 cm).

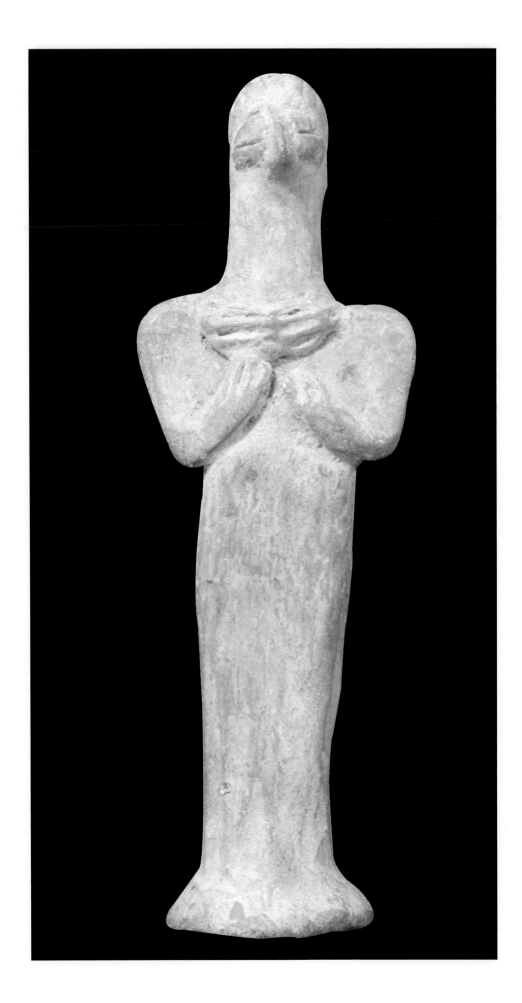

\mathcal{G}od respects me when I work, but
loves me when I sing.

RABINDRANATH TAGORE

COLIMA SINGER

Colima, Jalisco, and Nayarit are terms for different ceramics styles that appeared in western Mexico 2,000 years ago. Little is known about the individual cultures; however, their pottery figures are exceptional, even for an area that was one of the world's great producers of art pottery. These figures, which can be divided into two main groups, large and hollow or small and solid, are generally found in great shaft tombs, which are unique to this area of Mexico. The Colima woman opposite (of the small and solid type) is an excellent example of the remarkable ability of the artisans to capture subtlety in clay. By raising her clasped hands to her throat, and slightly opening the cowrie-shaped mouth, the sculptor brought a potentially stiff traditional piece alive, as a singer.

*. Western Mexico; 100 BC–300 AD; low-fired clay;
height 4.75 inches (12 cm).*

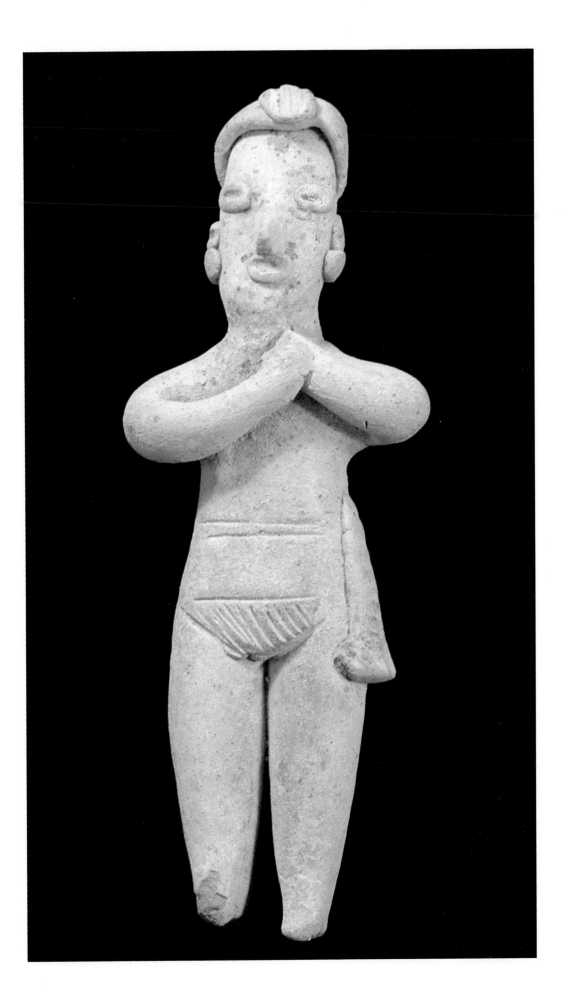

Behind Me—dips Eternity—
Before Me—Immortality—
Myself—the Term between—

EMILY DICKINSON

The T'ang Dynasty, one of China's greatest, is best known for exceptional cultural achievements in poetry, art, and music. Founded in 618 AD after 350 years of political instability, it lasted until 906. In 637, a twelve-year old girl named Wu Chao joined the Emperor T'ai Tsung's harem. Banished to a nunnery after his death in 649, she returned to court six years later as Empress to his son, Kao Tsung. When he fell ill in 660, Wu Chao ruled with absolute power over a nation of 50 million people until his death in 683. She then did away with his sons and continued to rule until she was 82. The figurine opposite may represent a lady from Wu Chao's court.

. China; seventh century; glazed pottery; height 12.25 inches (31 cm).

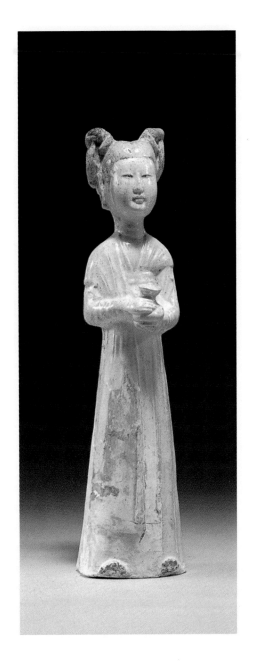

To live is so startling it leaves little time for anything else.

EMILY DICKINSON

The Minoans, considered by many to have founded Europe's first great civilization, flourished on Crete between 2200 and 1450 BC. Their name derives from King Minos, whose beautiful, 1,500-room palace at Knossos was such a maze of rooms and corridors that it may have inspired the story of the Labyrinth and the Minotaur. The palace was filled with remarkable murals depicting dolphins, flying fish, acrobats leaping over bulls, and elaborate rituals and processions. Archaeologists speculate that the women of this culture shared a high degree of equality with men. The Minoans didn't use public temples; instead they worshipped an earth goddess in sacred caves and hilltop sanctuaries. A violent eruption (circa 1450 BC) of the volcano Santorini, in the Cyclades 60 miles to the northeast, may have initiated the Minoan decline. The goddess opposite was found in a storeroom in the ruins of the Knossos palace.

. Knossos Palace, Crete, Greece; 1600 BC; ceramic; height 7.5 inches (19.5 cm).

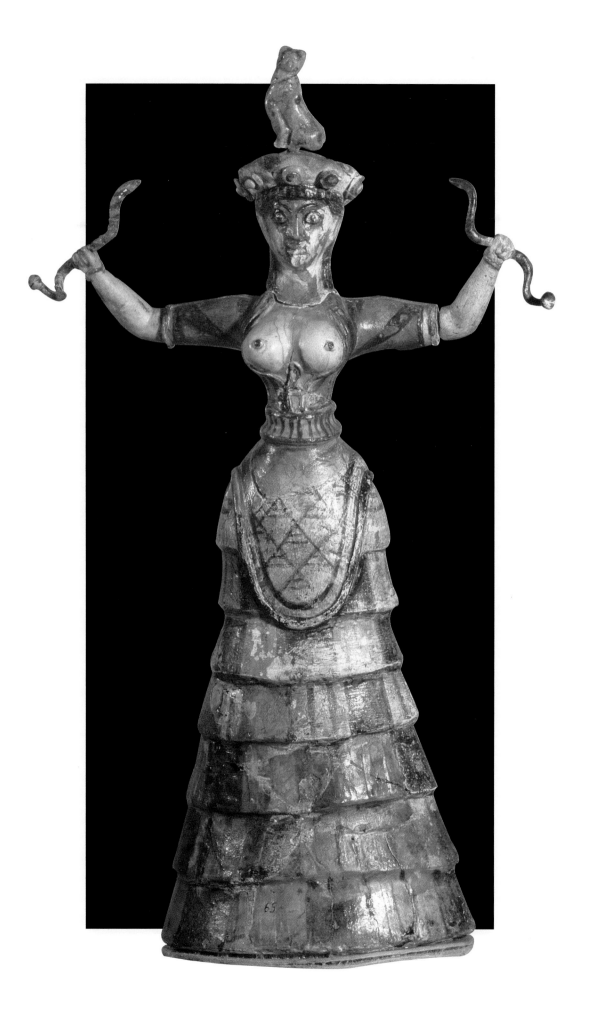

*D*on't you hear it? she
asked & I shook my head
no & then she started to
dance & suddenly there
was music everywhere &
it went on for a very long
time & when I finally
found words all I could
say was thank you.

BRIAN ANDREAS

CELTIC DANCER

The Celts, a diverse people united by a common language and religion, first appeared in Europe around 800 BC. They grew so powerful that in 290 BC, they sacked Rome and gained control of lands from Turkey to the British Isles. Accounts tell of Celtic women skillfully averting war through diplomacy, and failing that, leading armies into battle. In the fourth century AD, Ammianus Marcellinus wrote that when a Celtic man was outnumbered, he would call his wife, who would come run-ning, with eyes flashing, to attack the enemy so ferociously that they would flee in terror. Celtic women had more personal freedom than Greek or Roman women, and Roman society was scandalized by their open sexuality. This cast bronze dancer seems to reflect the sense of ease they felt with their bodies.

. France; circa 200 BC; cast bronze; height 5.5 inches (14 cm).

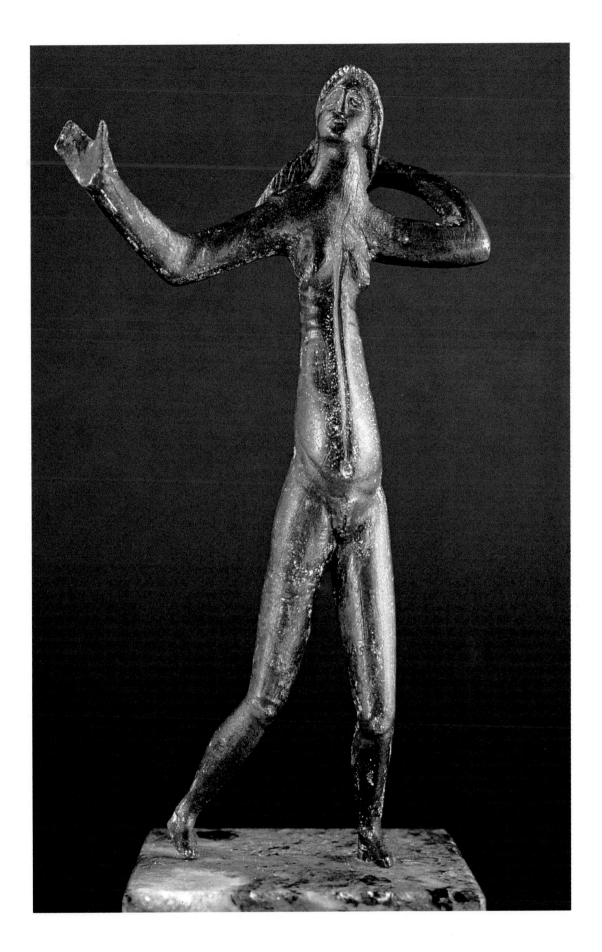

Oh, think not I am faithful to a vow!
Faithless am I save to love's self alone.

EDNA ST. VINCENT MILLAY

INDUS VALLEY DANCER

The Indus Valley culture arose on the banks of the Indus River around 2500 BC in what is now Pakistan. Along with Mesopotamia, Egypt, and China, it is considered one of the world's first true civilizations. This bronze dancing figurine came from Mohenjo-Daro, one of two major Indus communities. It was a beautifully designed city with wells, private indoor bathrooms, large public baths, and even covered manholes so drainpipes could be serviced. Huge grain storage buildings were specially constructed to allow air to circulate under the floors. This great city died in a most unusual way. Tectonic plates shifted, the land between the city and the sea rose, and Mohenjo-Daro and its surrounding farms flooded and became swampland. Little is known about the religious life of this people, but the abundance of female statues suggests goddess worship.

. Indus Valley, Pakistan; 2500 BC; cast bronze; height 4.25 inches (10.75 cm).

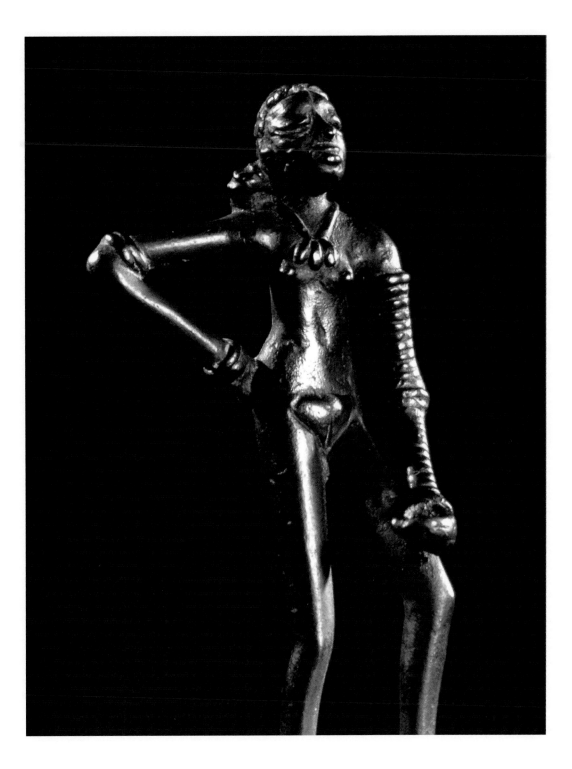

I, being born a woman and distressed
By all the needs and notions of my kind,
Am urged by your propinquity to find
Your person fair, and feel a certain zest
To bear your body's weight upon my breast:
So subtly is the fume of life designed,
To clarify the pulse and cloud the mind,
And leave me once again undone, possessed.
Think not for this, however, the poor treason
Of my stout blood against my staggering brain,
I shall remember you with love, or season
My scorn with pity,—let me make it plain:
I find this frenzy insufficient reason
For conversation when we meet again.

EDNA ST. VINCENT MILLAY

MAENAD SATYR

Maenads and satyrs were followers and companions of Dionysus, the Greek god of intoxication, pleasure, music, and dance. It was Dionysus who taught humans to grow grapes and make wine. Maenads were young, graceful, beautiful nymphs, who along with satyrs were the elemental spirits of the mountains and forests. They spent their time cavorting in the woods, laughing, singing, dancing, and celebrating life, as depicted in this wonderful fifth-century BC Etruscan sculpture. During the grape harvest, women dressed as maenads would perform a wild dance of "sacred madness" symbolic of regeneration, then men costumed as satyrs would dance, all while other performers would act out Dionysus' words. These dances were the beginnings of Greek theater. This Maenad seems to have a patient, bemused look on her face.

. Tuscany, Italy; 475 BC; terracotta; height 23.5 inches (59.5 cm).

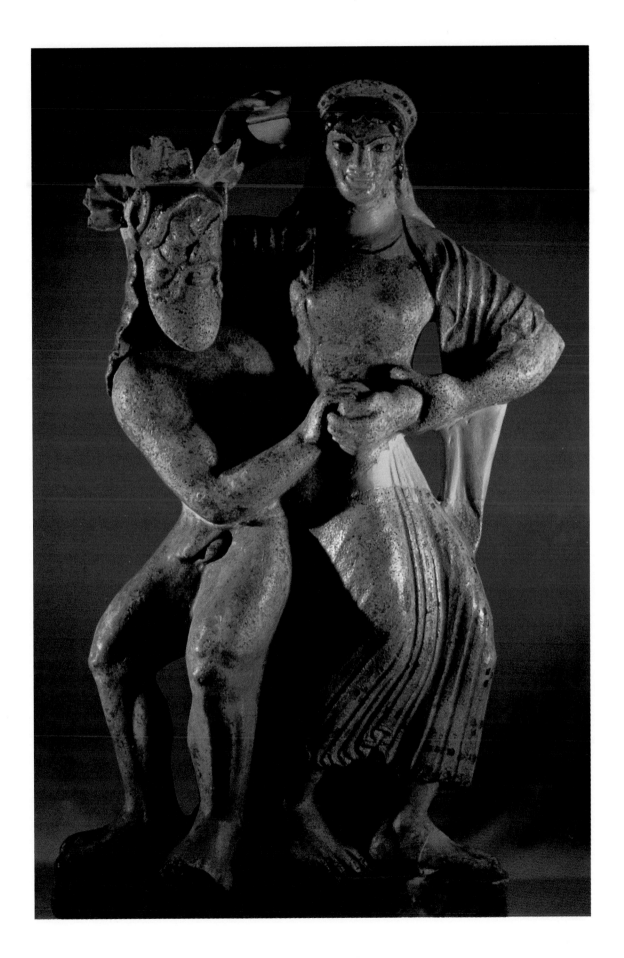

My heart is filled with joy when I see you here,
as the brooks fill with water
when the snow melts in the spring;
and I feel glad as the ponies do
when grass starts in the beginning of the year.

PARRA-WA-SAMEN (TEN BEARS)

This ceramic mother and child figure was found at Cahokia, a metropolis that flourished around 1000 AD on the banks of the Mississippi River in an area now known as East St. Louis. At its peak, the city may have had 15,000 inhabitants; the remains of more than 120 large earthen mounds have been discovered there. The largest is the 100-foot-high Monk's Mound, with a base three acres larger than that of the Great Pyramid in Egypt. Cahokia was not the only area of mound building; more than 10,000 have been found in the Ohio Valley alone. Many were shaped like birds and reptiles, like the quarter-mile-long Serpent Mound near Cincinnati, built over 2,000 years ago. The Cahokia sculpture opposite is one of the finest figurative works from pre-Columbian North America.

. Missouri; circa 1300 AD; fired clay; height 5.5 inches (14.9 cm).

30

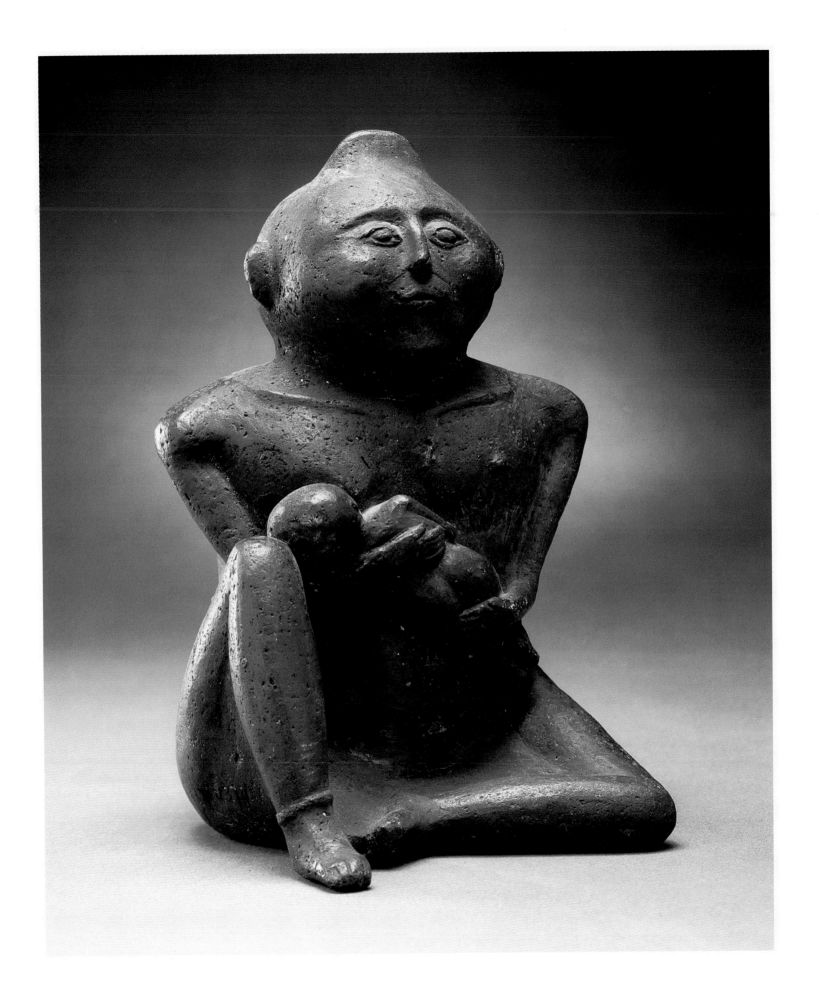

*I was always looking outside myself
for strength and confidence,
but it comes from within,
it is there all the time.*

<div align="right">ANNA FREUD</div>

The Etruscans flourished between 800 and 200 BC along the northwest Italian coast in an area known today as Tuscany. Their origins are uncertain, but by the sixth century BC they had become a single people, occupying twelve city-states, with a common language and culture. Rich volcanic farmland, abundant mineral deposits, and great creative energy enabled them to grow strong and wealthy through trade. Because of their fierce independence and unwillingness to unite their states, they were badly weakened by a series of defeats at the hands of the Celts and Greeks, and were finally overthrown by a successful Roman revolt in 200 BC. This fine terracotta woman's head was found in the ruins of Veii, once a major Etruscan city.

. Etruscan; Veii; Tuscany, Italy; circa 480 BC; terracotta; height 11 inches (4.3 cm).

32

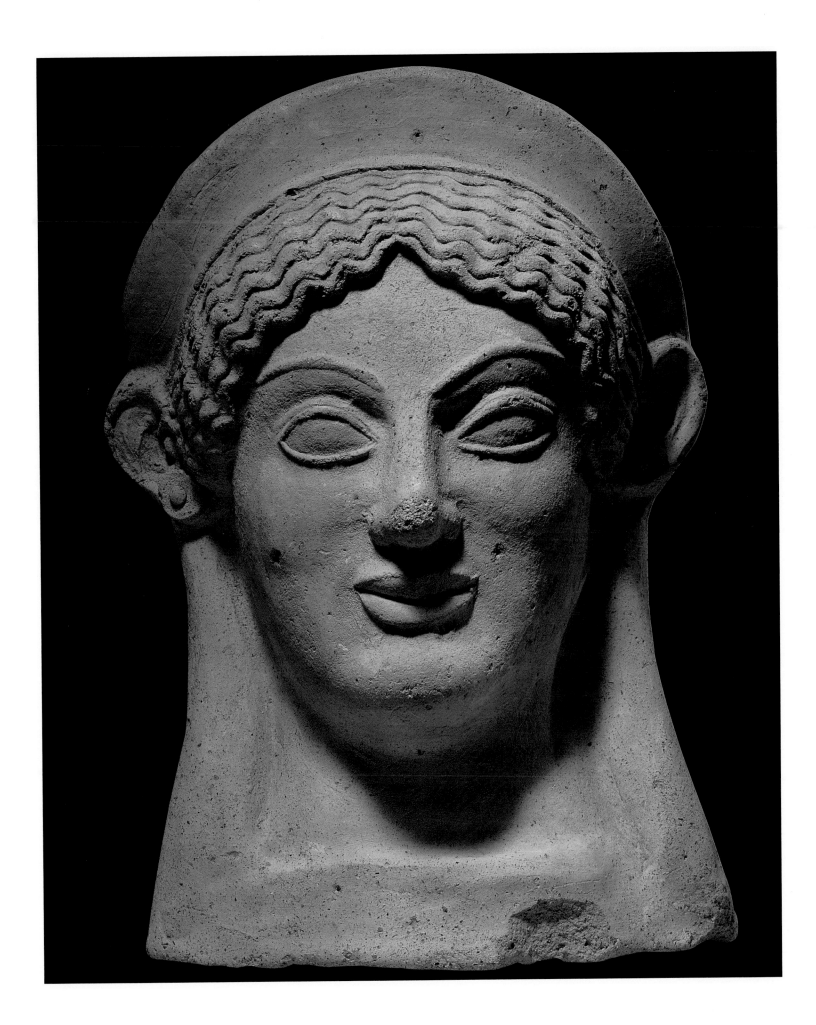

What lips my lips have kissed, and where, and why,

I have forgotten, and what arms have lain

Under my head till morning; but the rain

Is full of ghosts tonight, that tap and sigh

Upon the glass and listen for reply,

And in my heart there stirs a quiet pain

For unremembered lads that not again

Will turn to me at midnight with a cry.

Thus in the winter stands the lonely tree,

Nor knows what birds have vanished one by one,

Yet knows its boughs more silent than before:

I cannot say what loves have come and gone,

I only know that summer sang in me

A little while, that in me sings no more.

EDNA ST. VINCENT MILLAY

DEMETER

Demeter was the golden-haired Greek goddess who gave agriculture to humanity. She was one of the twelve deities who reigned from Mount Olympus, which rises sharply to 9,000 feet near the shores of the Aegean. Because of her great beauty, Demeter was pursued by the gods, and with Zeus she had a daughter, Kore. The story of Kore's abduction (page 36) and her mother's desperate search for her were the central themes of the Eleusinian Mysteries, for 2,000 years the most sacred festival in ancient Greece. Every February the Lesser Mystery celebrated Kore's return (spring), while every five years the Greater Mystery honored Demeter. Participants were sworn to secrecy, but modern research suggests they consumed a hallucinogenic potion prepared from ergot (a cereal fungus). Demeter's expression here reflects her grief at Kore's disappearance.

. Boeotia, Greece; circa 460 BC; terracotta; height 13.9 inches (35.2 cm).

34

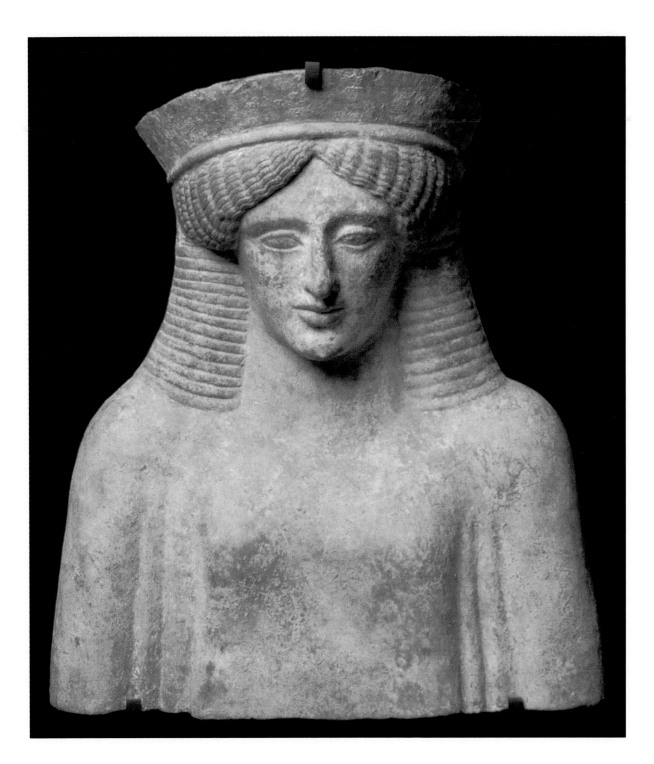

The most profound relationship we'll ever have is the one with ourselves.

SHIRLEY MACLAINE

KORE / PERSEPHONE

Kore (maiden) was the beautiful daughter of Demeter and Zeus. One day, as she stooped to pick a narcissus, the ground beneath her suddenly ripped open and Hades, lord of the underworld, reached up, snatched her, and carried her back to his home beneath the earth. When Demeter learned that Zeus had condoned the abduction of Kore (renamed Persephone since her descent into the realm of the dead), she was so enraged that she caused all the crops on earth to wither and die, resulting in widespread famine. At last, in desperation, Zeus intervened and ordered Hades to restore Persephone to her mother. Hades agreed, but first persuaded Persephone to eat a few pomegranate seeds, thereby tricking her into becoming his wife. As his queen Persephone had to return to rule the underworld for four months of each year. In her grief, Demeter prevented the crops from growing, thereby creating winter, for as long as her beloved daughter dwelt underground. Here is a strong woman, unbowed by fate.

. Athens, Greece; circa 500 BC; height approx. 27 inches (68.6 cm).

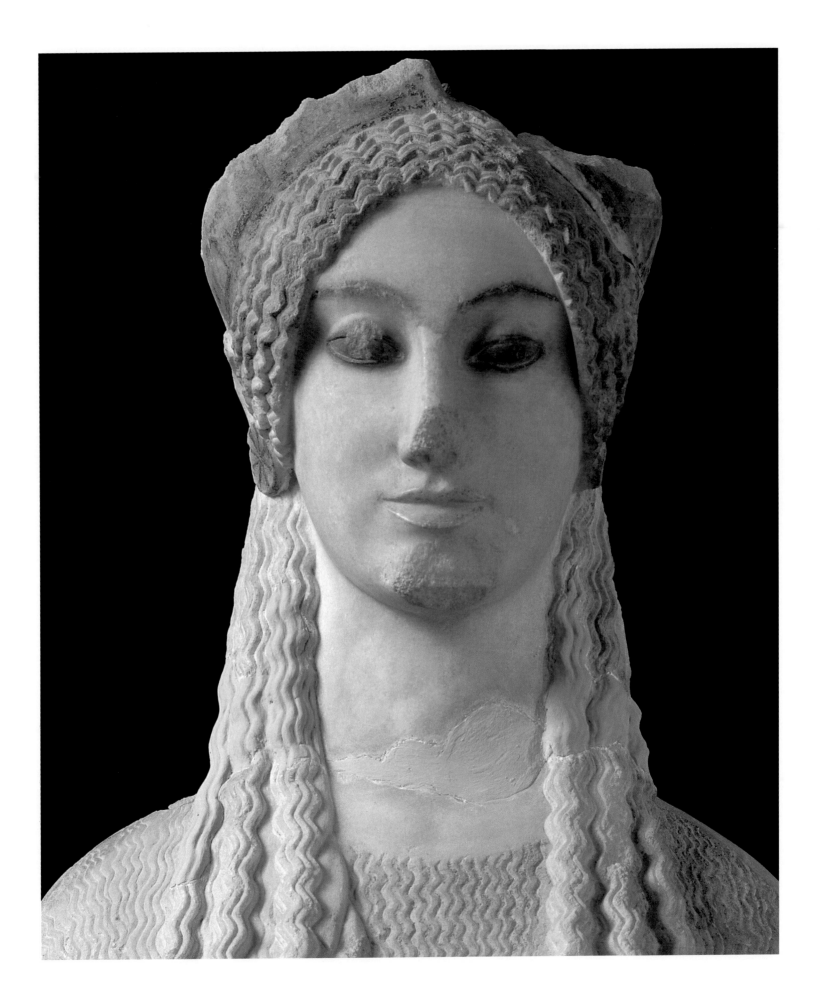

The day will come when man will recognize woman as his peer, not only at the fireside, but in the councils of the nation. Then, and not until then, will there be perfect comradeship, the ideal union between the sexes that shall result in the highest development of the race.

<div align="right">SUSAN B. ANTHONY</div>

ETRUSCAN LADY

Etruscan women enjoyed more freedom, and were treated with greater equality in society, than either Greek or Roman women. They used personal names, whereas Greek and Roman women were identified as their father's daughter or their husband's wife. Etruscan women also had an influence on how their children would be raised, while Greek and Roman women did not. Their freedom seemed particularly upsetting to some outsiders. Theopompus, a fourth-century BC Greek historian, was shocked, and wrote that Etruscan women were overtly pleasure-loving, waxed their bodies to remove hair, exercised nearly naked, ate dinner with men other than their husbands, and toasted anyone they chose!

. Tuscany, Italy; circa 300 BC; terracotta; height 11.6 inches (14.25 cm).

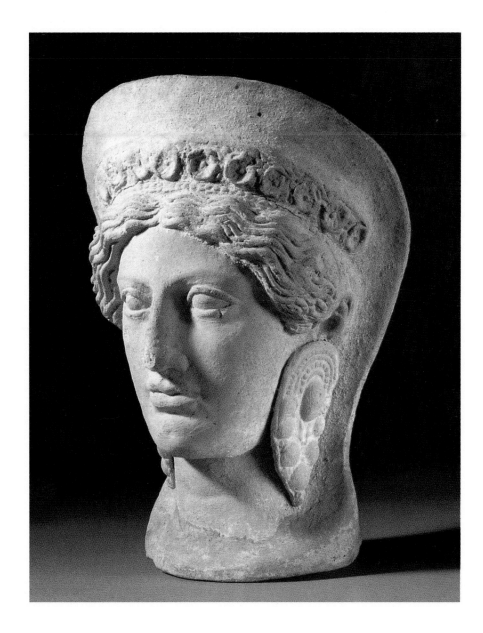

*Love from one being to another
can only be that two solitudes come nearer,
recognize and protect and comfort each other.*

RANIER MARIA RILKE /HAN SUYIN

ETRUSCAN COUPLE

Because no Etruscan literature has ever been found, and Greek and Roman accounts are biased, much of what is "known" about Etruscan women has been surmised from the lavishly decorated tombs of those who could afford them. These contained not only exquisitely made jewelry, cosmetics, and amber (treasured by women for its magical properties), but furniture, and even an occasional chariot. Tomb murals show beautifully dressed women eating, drinking, and dancing with their husbands and guests, customs unknown to Greeks and Romans. Roman women were not even permitted to drink, and at Greek parties, the only women welcome were "entertainers." This terracotta sarcophagus of a husband and wife, reclining together, beautifully illustrates Etruscan gender equality.

. Tuscany, Italy; 580 BC, terracotta; height 78 inches (2 m).

40

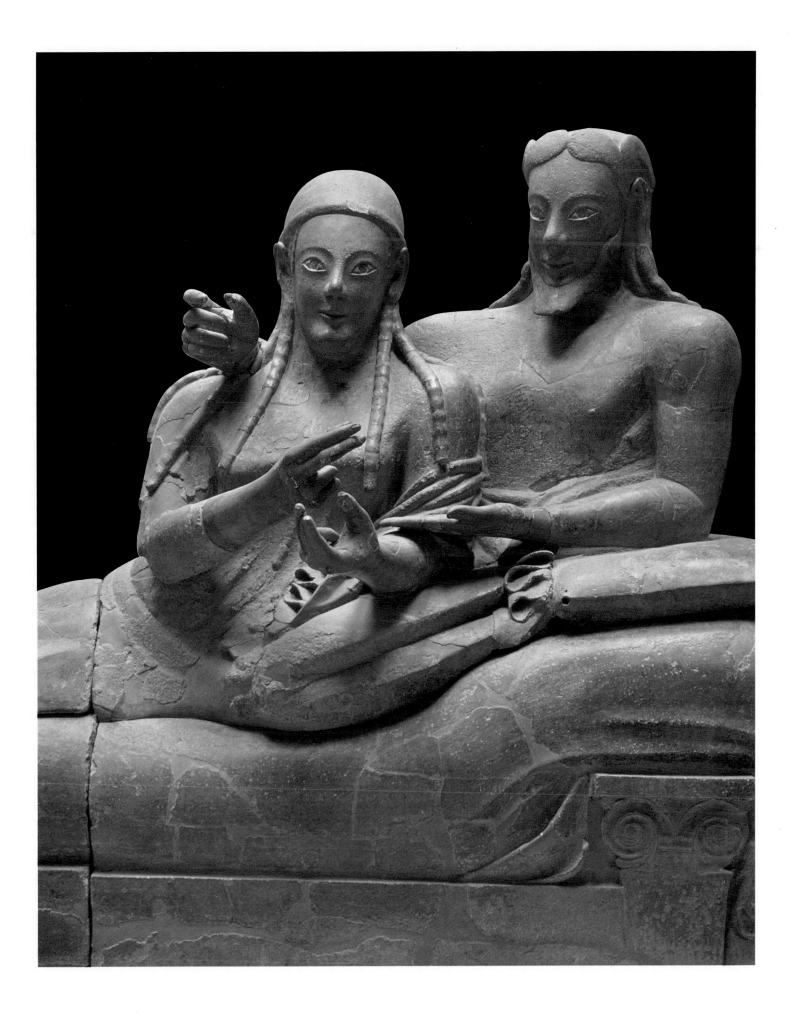

*W*ild Nights—Wild Nights!
Were I with thee
Wild Nights should be
Our luxury!

Futile—the Winds—
To a heart in port
Done with the compass
Done with the chart!

Rowing in Eden—
Ah, the sea!
Might I but moor—Tonight—
In thee!

EMILY DICKINSON

VRIKSHAKA

The Aryans of Iran invaded, conquered, and settled in the Indus Valley of India about 1500 BC, and though they struggled to maintain their traditions, inevitably, changes occurred. The Aryan social classes of Iran altered to become the Aryan caste system of India, with Brahmans as the new priestly caste from which the transformed religion got its name. Thus, Vedic Hinduism became Brahmanic Hinduism. In Brahmanic mythology, Vrikshakas were tree nymphs who haunted trees and sacred groves, and, along with water nymphs, Apsaras, changed over time to become the sacred dancers and singers of heaven. Brahmanism's highest god was Indra, who rode the sun, and wielded thunder and lightning. In this beautiful stone temple carving, the Vrikshaka has the idealized form given most Indian goddesses.

. India; ninth century AD; stone; height approx. 14 inches (35.5 cm).

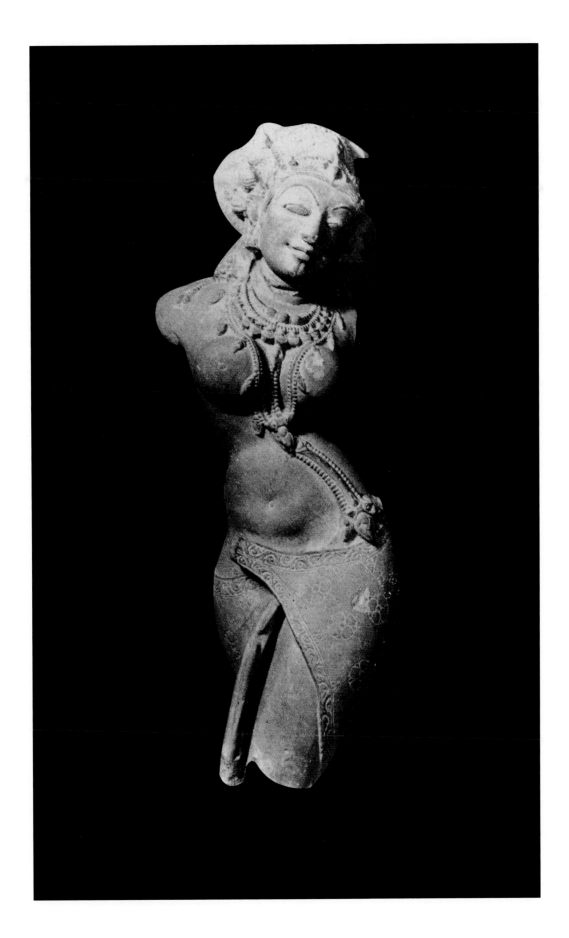

I used to wait for a sign, she said,
before I did anything. Then one
night I had a dream & an angel in
black tights came to me & said,
You can start any time now & then
I asked is this a sign? & the angel
started laughing & I woke up.
Now, I think the whole world is
filled with signs, but if there's
no laughter, I know they're
not for me.

BRIAN ANDREAS

JAIN MOTHER GODDESS

This stone temple carving shows Parvati as the Jain Mother Goddess. Jainism (like Buddhism) is an offshoot of Hinduism, and concerns itself with how to escape the cycle of suffering and rebirth. Instead of worshipping deities, the Jains believe in a series of great teachers (Tirthamkaras) who, after they have escaped mortality, stay to help others, much like Buddhist Bodhisattvas. Each person is, however, ultimately responsible for her or his own destiny. More extreme Jains wear gauze over their mouths, and sweep the paths in front of themselves, so that they won't accidentally kill any insects, and thereby take on more Karma. Goddesses and gods (inherited from Hinduism) are below Tirthamkarases in Karmic evolution, and must become human before they can attain deliverance. Goddess Parvati represents Lord Shiva's power in the physical realm, and she appears in many forms. Durga, on page 89, is another of her persona.

. Orissa, India; eleventh century AD; stone; height 30 inches (76 cm).

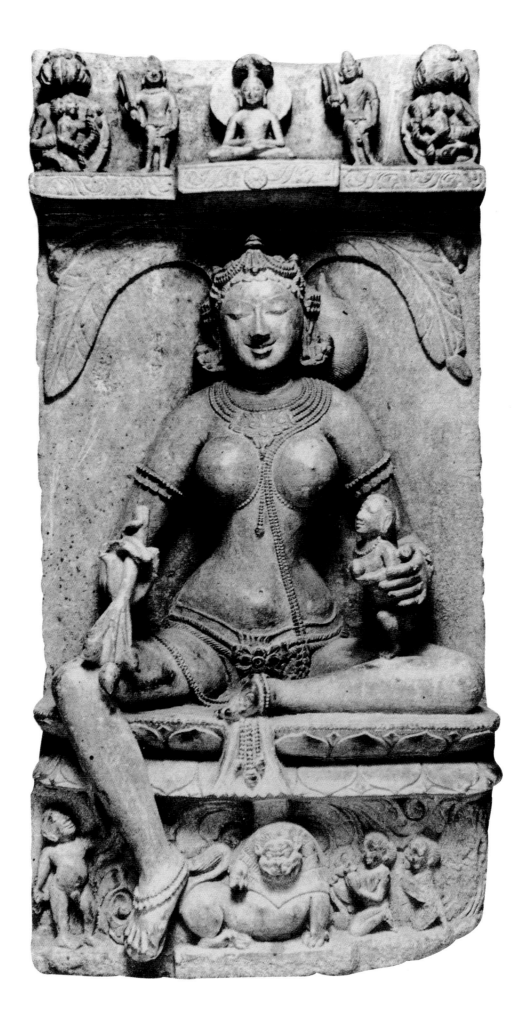

Love is a fruit in season at all times,
and within the reach of every hand.

MOTHER TERESA

GODDESS KUAN YIN

Known as "the lady who brings children," Kuan Yin is a symbol of compassion. For Buddhists she is the goddess of mercy and fertility, and a great healer. Every year crowds of pilgrims gather at the Mountain of the Wondrous Peak (near Beijing) to honor her and pray at her temple. According to myth, there was a time when rice plants existed, but did not produce rice. Seeing that the people were hungry, Kuan Yin slipped quietly into the fields one night and squeezed the milk from her breasts to fill the plants; the milk then became rice. Nearing the end of her task, and being almost out of milk, she had to squeeze so hard that she bled, and her blood mixed with the milk. This is why, it is said, we have both white and brown rice.

. China; circa seventeenth century; polished stone;
height approx. 7 inches (17.8 cm).

46

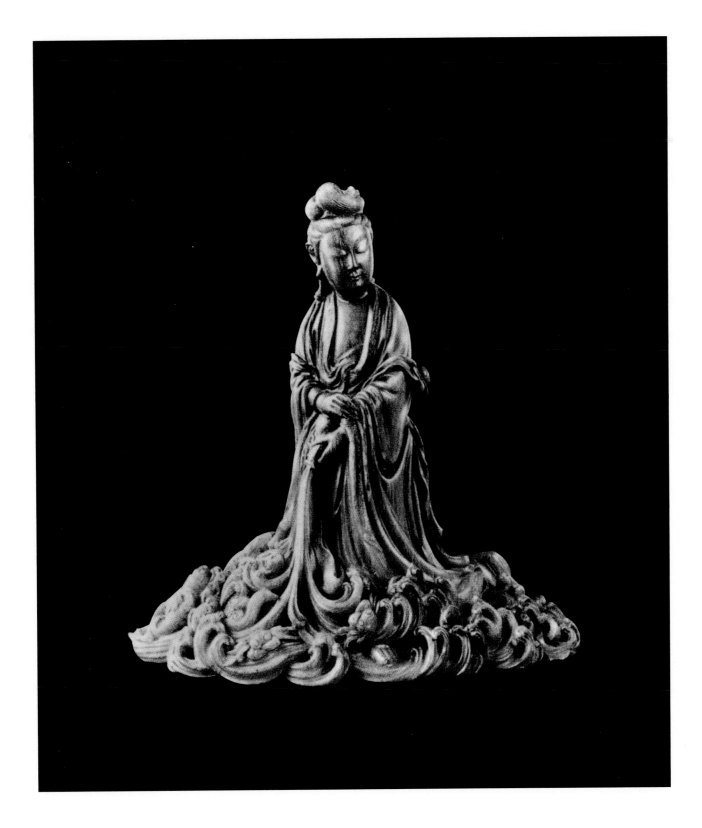

If particular care and attention is not paid to the ladies,
we are determined to ferment a rebellion
and will not hold ourselves bound by any laws
in which we have no voice or representation.

ABIGAIL ADAMS

MAYAN NOBLEWOMAN

The Mayans, who date back to 2000 BC, were the most widespread and evolved of the pre-Columbian, Mesoamerican peoples. At the height of their culture between 250 and 950 AD, they built great ceremonial centers with stone pyramids, some over 230 feet high, and surrounding cities with populations of nearly 50,000. They developed a system of writing using glyphs, and excelled at calendar making and astronomy. Social classes were sharply divided, with an elite that oversaw masses of warriors, farmers, and laborers. Blood was considered sacred, and was spilled to honor the gods. Prisoners were captured for sacrifice, but bloodletting was also thought to be a personal honor, and both women and men practiced it on themselves. This noblewoman's cheeks are scarred from the corners of her mouth to her ears.

. Jaina; Central America; 550–950 AD; fired clay; height 6.5 inches (16.5 cm).

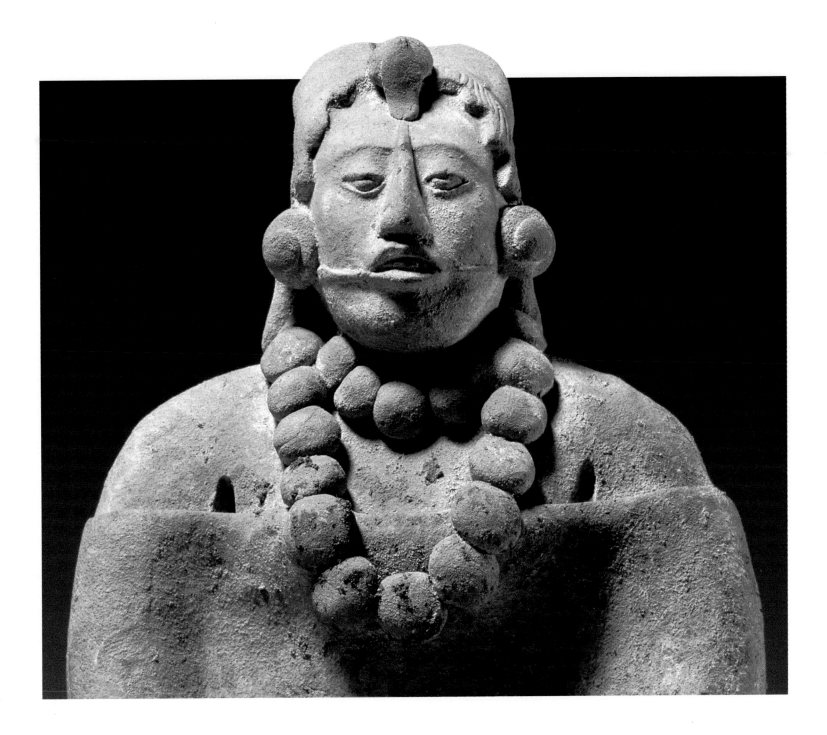

I survived because I was tougher than anybody else.

BETTE DAVIS

QUEEN HATSHEPSUT

When her father Pharaoh Tuthmosis I died, Princess Hatshepsut married her half-brother to strengthen his claim (women were not permitted to rule). He became Pharaoh Tuthmosis II, and she became Queen. Ten years later he died without their having produced a royal heir, so a nine-year-old son by a minor concubine was made Pharaoh Tuthmosis III, with Hatshepsut as his regent. She was extremely bright and ambitious, and within two years had garnered enough support in court to usurp the throne and exile the young King. Queen Hatshepsut then guided Egypt through twenty years of peace and prosperity, an amazing feat for any ruler in those turbulent times. She directed that her tomb be built in the Valley of Kings, with her Mortuary Temple (a magnificent blending of gardens and architecture) just outside. Here she is depicted as Pharaoh, wearing the beard that is symbolic of Pharaonic power.

. Deir-el-Bahri, Egypt; 1490–1470 BC; painted limestone;
height 24 inches (61 cm).

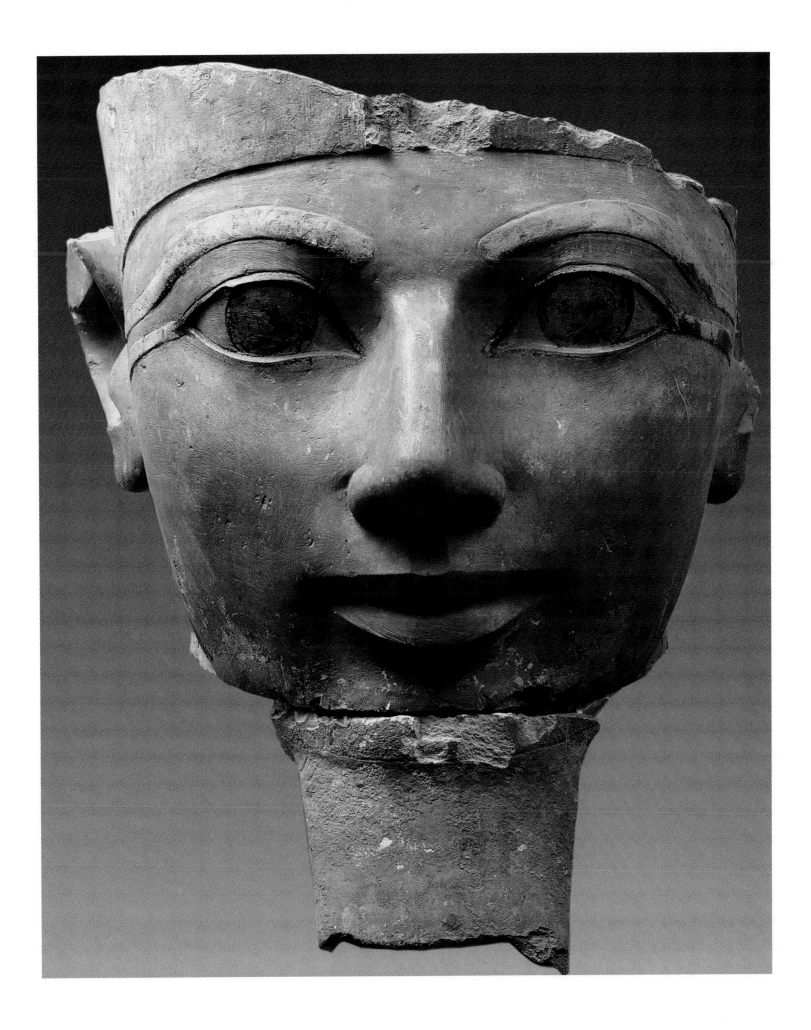

Nothing is less real than realism.

GEORGIA O'KEEFFE

GODDESS SEKHMET

Sekhmet "the mighty one," Egyptian goddess of war, was depicted as a lion, or a woman with a lion's head. Originally she was Hathor, goddess of women, love, music, and dance, who turned herself into a lion to punish men who had rebelled against the Sun God Ra. She was a ferocious killing machine, and in order to save mankind Ra had to trick her into getting drunk on beer and pomegranate juice (which she mistook for blood). Sekhmet struck a responsive chord, and the new goddess was established. (Hathor continued to be worshipped separately.) She accompanied the king into battle, protecting him and spreading terror around him. A fiery glow radiated from her; the hot desert wind was thought to be her breath. In Thebes (Luxor) she merged with Mut, a local mother goddess, and the diorite statue opposite is one of 600 that Amenhotep III, Nefertiti's father-in-law, commissioned to elevate the goddess to national status as Mother of the Sun.

. Thebes, Egypt; 1390–1353 BC; diorite; height 43 inches (109.2 cm).

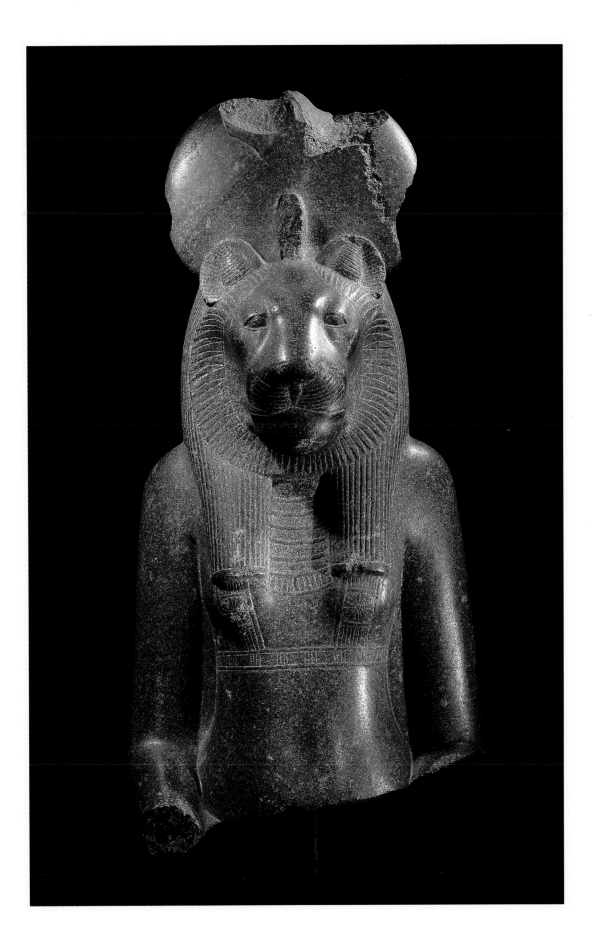

That man over there says that women need
To be helped into carriages, and lifted
Over ditches, and to have the best place everywhere.
Nobody ever helped me into carriages, or over
Mud puddles, or gives me the best place!
> *And ain't I a woman?*

Look at me! Look at my arm!
I have plowed and planted, and gathered
Into barns, and no man could head me!
> *And ain't I a woman?*

I could work as much and eat as much
As a man...when I could get it!
And bear the lash as well!
> *And ain't I a woman?*

I have borne thirteen children, and seen
Them most all sold off to slavery;
And when I cried out with my mother's grief,
None but Jesus heard me.
> *And ain't I a woman?*

Then that little man in black there, he says
Women can't have as much rights as men,
'Cause Christ wasn't a woman.
> *Where did your Christ come from?*

From God and a woman!
Man had nothing to do with him!
If the first woman God ever made was strong
Enough to turn the world upside down all alone,
Women together ought to be able to
> *Turn it back, and get it right side up again!*

SOJOURNER TRUTH

WOMAN BREWER

This painted limestone statue was discovered in Princess Meresankh's tomb in Giza (her father, Pharaoh Cheops, was the builder of the Great Pyramid). It was thought that when the princess would be called on to do work in her afterlife, this statue would come magically to life and do it for her. Here the woman is kneading a paste made of barley bread and water, which will be fermented to make beer. Bangs show from beneath her wig, and her tan skin shows her to be a servant, for men and female servants were depicted as tan. Queen Hatshepsut was a notable exception; she directed her images be tan as evidence that she had the same power as a pharaoh.

. Giza, Egypt; 2325 BC; painted limestone; height 11 inches (28 cm).

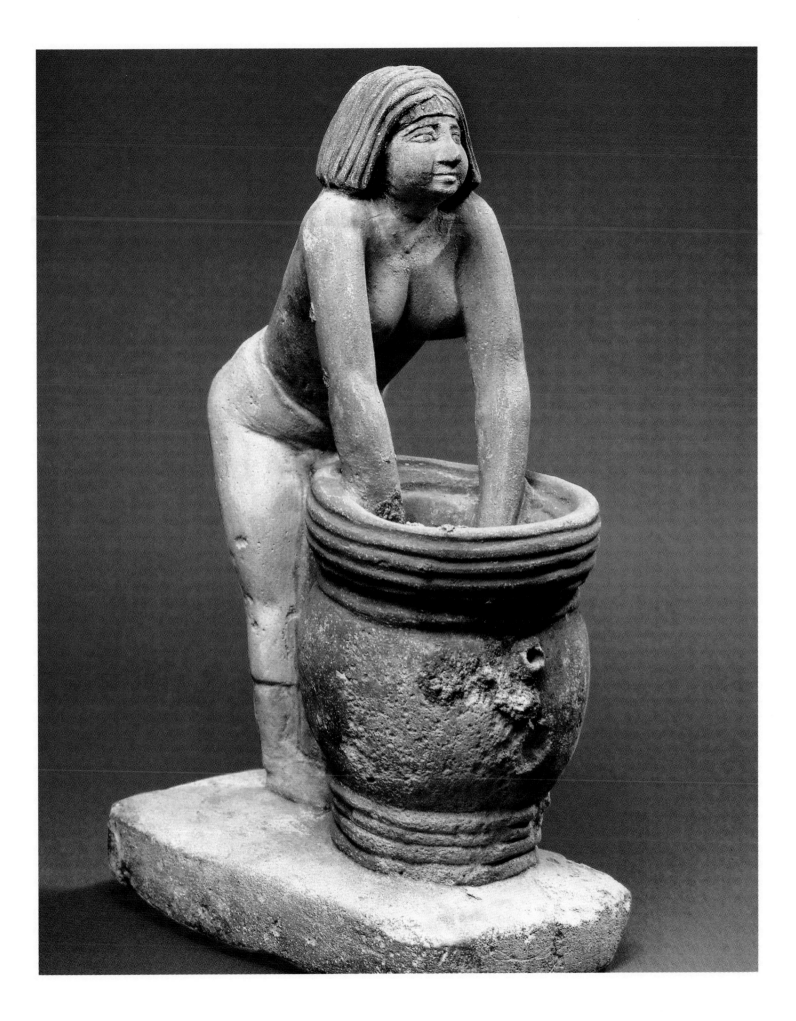

The best and most beautiful things in the world
cannot be seen or even touched.
They must be felt with the heart.

HELEN KELLER

LADY SENETITES

Senetites was a grand lady of the ancient Egyptian court, a priestess of Hathor and a priestess of Neith (a war Goddess). Her husband Seneb, chief of all the dwarfs who cared for the royal wardrobe, was also a priest in the funerary cult of King Cheops. Here Lady Senetites holds her husband proudly and lovingly with both arms. The children were carved with their fingers in their mouths to indicate their youth; for essential, overall balance, the artist placed the children where their father's legs would have been had he been full sized. This was a respected, wealthy family with elegant homes, and several thousand head of cattle.

. Egypt; circa 2475 BC; painted limestone; height 13.4 inches (34 cm).

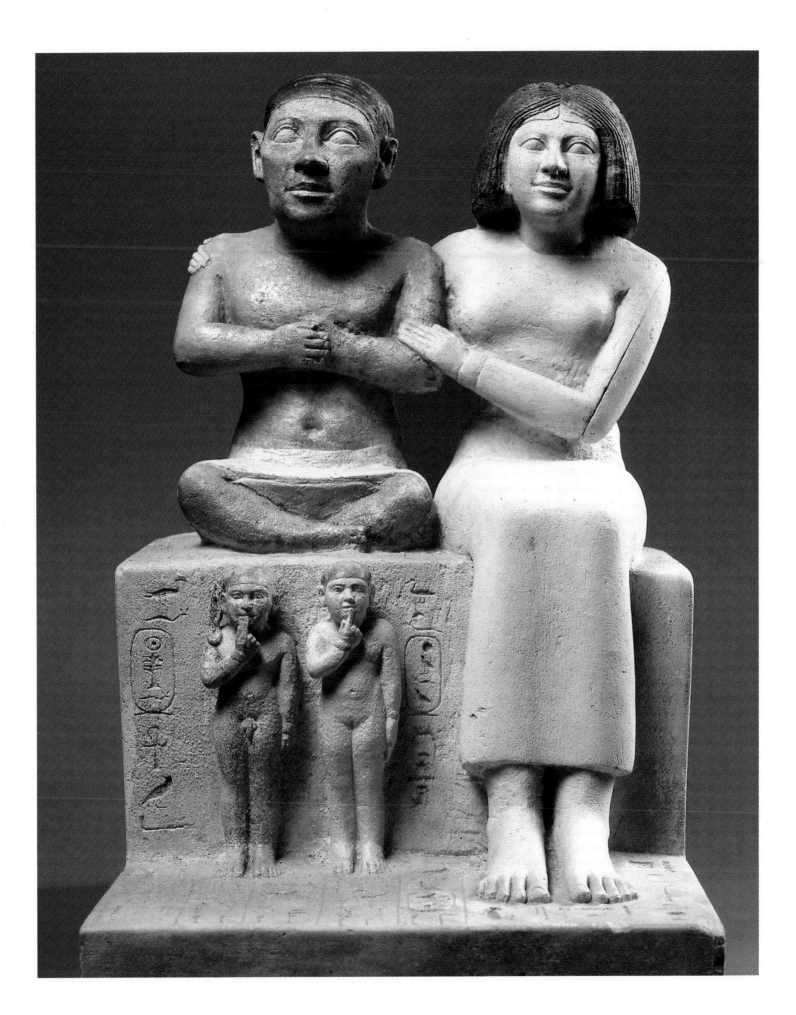

I seem to have loved you in infinite forms,
infinite times, in life after life,
in age after age forever.

<div align="center">RABINDRANATH TAGORE</div>

QUEEN MERIT-AMON

Merit-Amon, beloved daughter of Ramses II, became his "Great Royal Wife" when her mother Nefertari, his primary wife, died. Here Merit-Amon holds a statue of Hathor, a goddess-protectress of women, indicating that she was a priestess in her cult. In ancient Egypt, it was thought that the sun god rested for the night in Hathor's breast, to be reborn again each morning. This is perhaps why one of the Queen's nipples is portrayed as a sun-like flower. On her head is a crown of sacred Uraeuses (cobras), symbolizing royal authority. The Greek word uraeus comes from an Egyptian word meaning "she who rears up."

. Thebes, Egypt; circa 1271–1224 BC; painted limestone;
height 29.5 inches (75 cm).

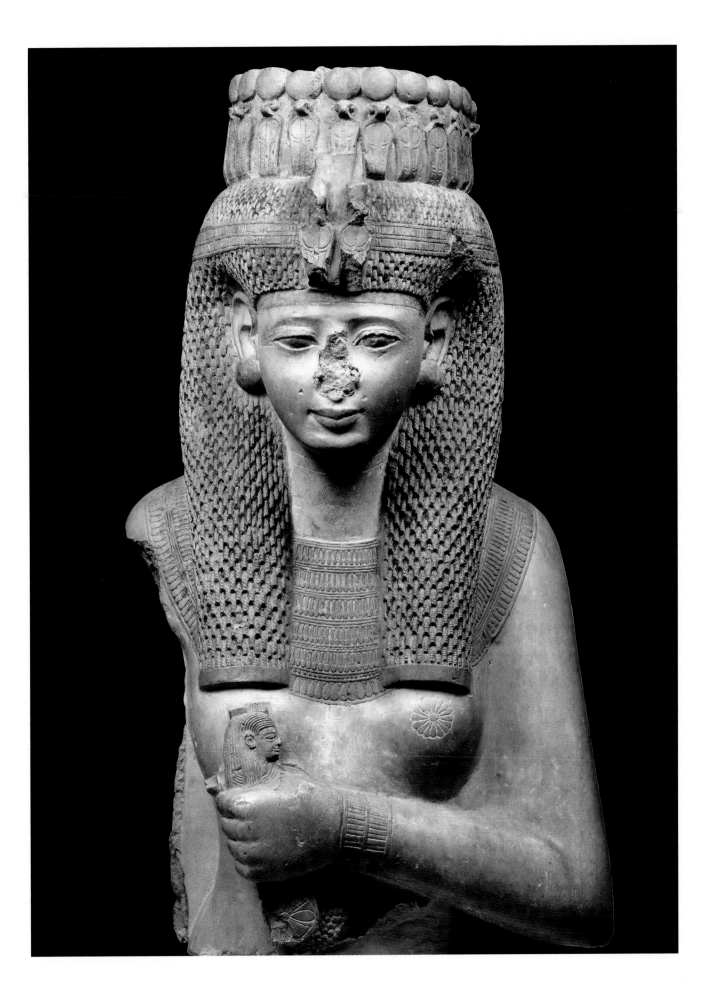

For the moon never beams without bringing me dreams
Of the beautiful Annabel Lee;
And the stars never rise but I feel the bright eyes
Of the beautiful Annabel Lee.

EDGAR ALLAN POE

MUMMY PORTRAIT

This lovely weathered painting of a young woman is Egyptian, done late in the Roman period (30 BC–395 AD). Many similar portraits have been found in the Fayuum, a lush area of farms 65 miles southwest of Giza and the Great Pyramid, hence the term "Fayuum portraits." Adding their personal touch to an ancient Egyptian practice, wealthy Greeks and Romans would have their portraits done as young adults, then save them to be placed on their mummies, in hopes of entering eternity wearing their "best" face.

. Egypt; circa 300 AD; wood panel; height 15.5 inches (14 cm).

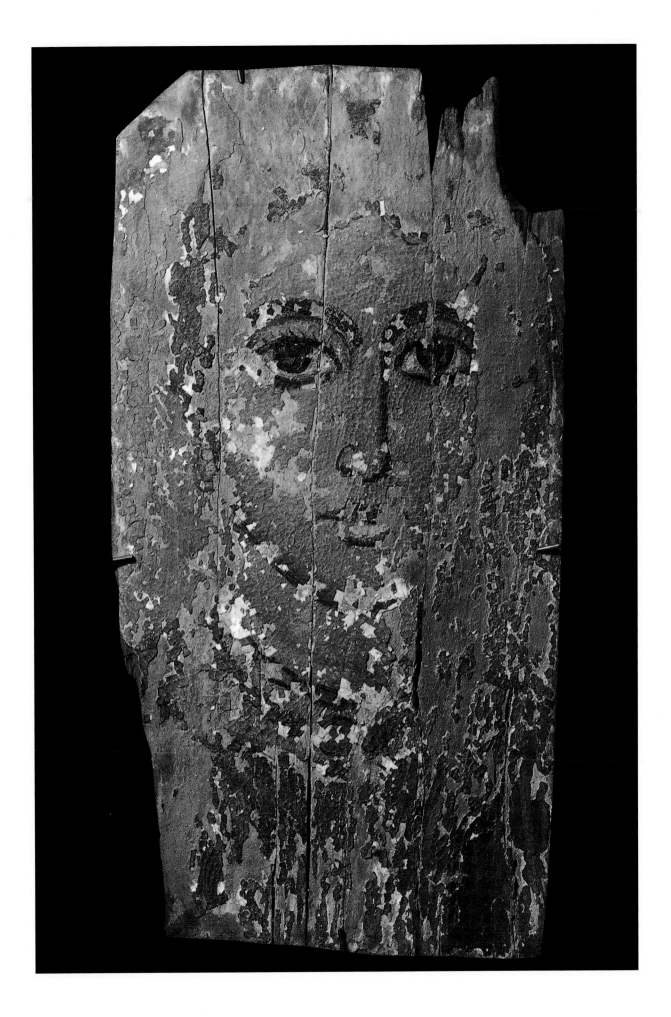

*Death is but a transition from this life to another . . .
and the only thing that lives forever is LOVE.*

ELIZABETH KÜBLER-ROSS

SPIRIT REVIVER

Often one of these figurines was placed in a man's tomb to help awaken his spirit at the beginning of his afterlife. The doll's female sexual nature and her power to arouse are strongly emphasized, but her body profile is phallic. Her hair is made of beads formed of Nile River mud. Every year when the Nile overflowed its banks, it deposited a new layer of rich soil in the valley. The Spirit Reviver's hair thus symbolizes rejuvenation and the possibility of new life.

*. Thebes, Egypt; 2000 BC; painted wood, mud beads;
height 9 inches (23 cm).*

62

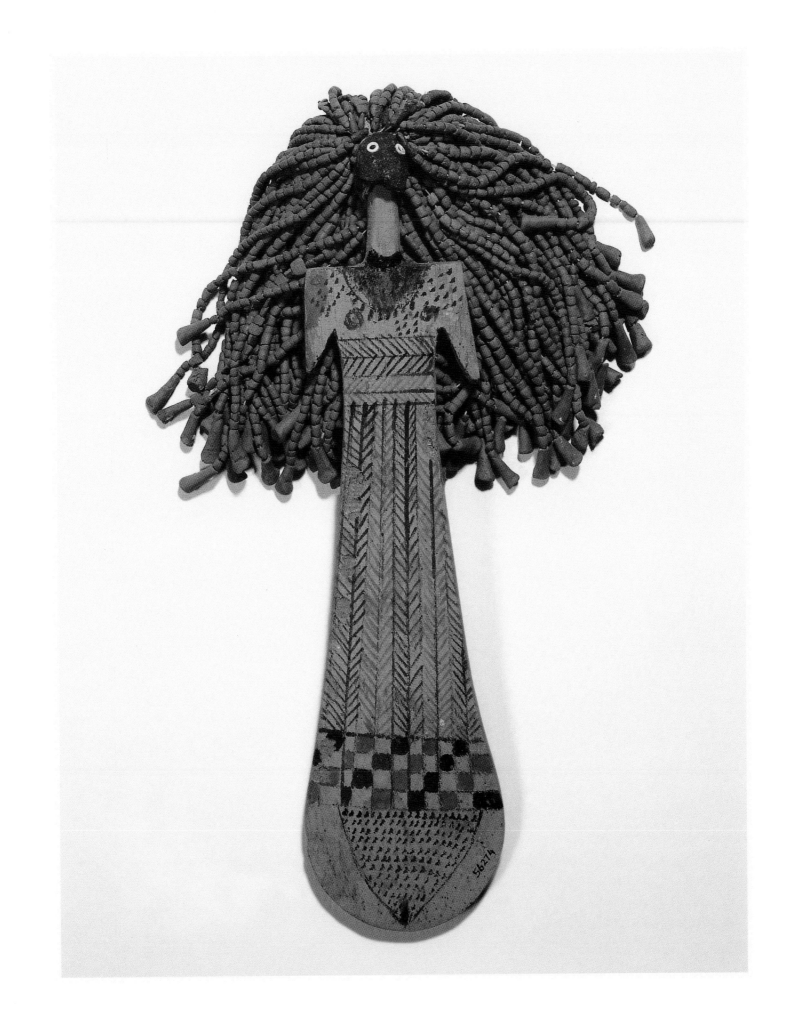

I have gazed at your beauty from the beginning of my existence,
. . . Yet it has not been long enough for me.

RABINDRANATH TAGORE

The Goddess Nut, daughter of moisture goddess Tefnut and air god Shu, personified the sky, and was often shown covered with stars, bent over and forming an arc, with her feet on the eastern horizon and her hands on the western horizon. This relief of her was carved on the underside of Pharaoh Merenptah's sarcophagus cover, with his figure carved on its top (opposite below). The Pharaoh intended to be quite literally "under" her protection for all eternity. However, 150 years later, Pharaoh Psusennes (1054–1004 BC) requisitioned the sarcophagus, had Merenptah's body removed, his names chiseled off (one on the belt buckle was missed), and his own name carved in their place. He planned to be the one to lie under this goddess forever. That was also not to be; the empty sarcophagus now rests in the Egyptian Museum in Cairo. A mirror, placed where the pharaoh lay, permits visitors to see the goddess's reflection.

. *Royal necropolis, Tanis, Egypt; 1220 BC; granite;*

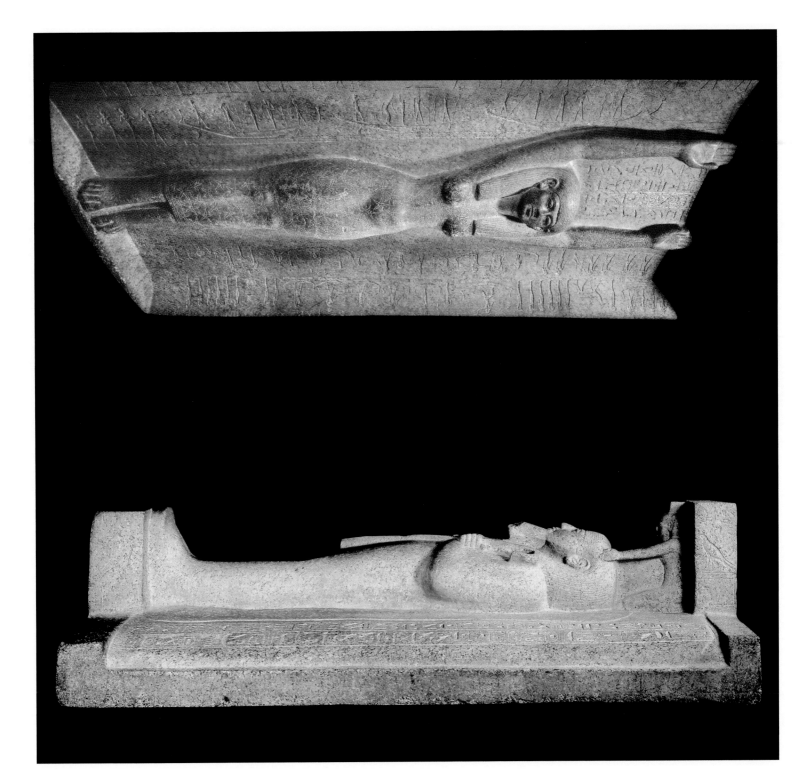

*W*e hold these truths to be self-evident:
that all men and women are created equal.

ELIZABETH CADY STANTON
SUSAN B. ANTHONY
MATHILDA GAGE

GODDESS SELKET

Selket was one of four goddesses who guarded coffins and canopic jars, in this case, Pharaoh Tutankhamen's. During mummification, the deceased's internal organs were placed in four canopic jars. Because the organs would be needed in the afterlife, elaborate precautions were taken to protect them. Originally, Selket protected people against the bites and stings of insects and arachnids, which is why she is depicted here with a scorpion on her head. This golden woman was also associated with the scorching heat of the sun. The slight turn of her head, as if she hears something behind her, is a break from the rigid manner in which Egyptian figures were traditionally rendered.

. Thebes, Egypt; gilded wood; 1337 BC; height 35.4 inches (90 cm).

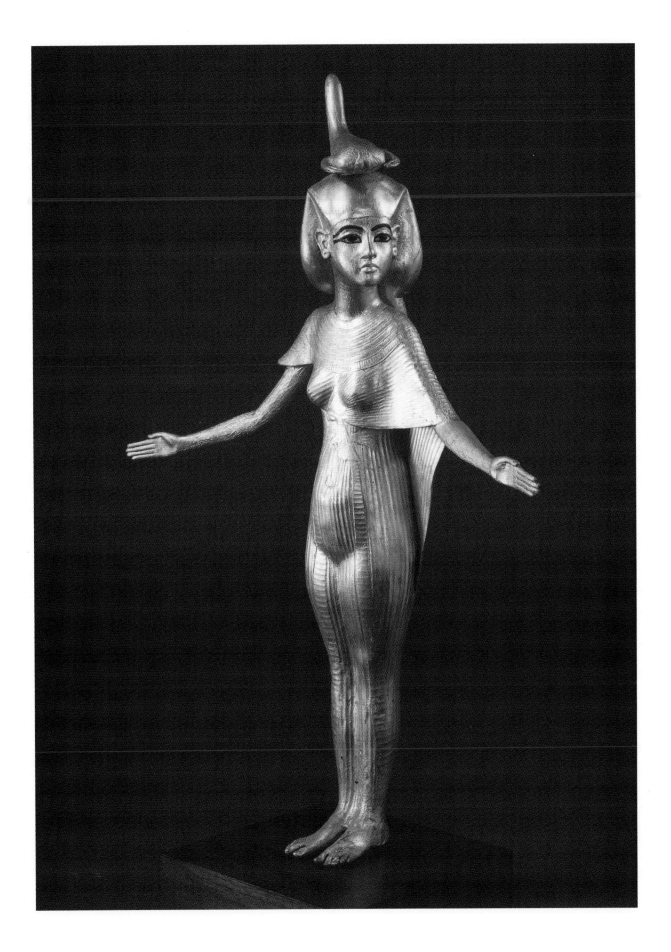

At each moment she starts upon a long journey and at
each moment reaches her end. . . . All is eternally present
in her, for she knows neither past nor future.
For her the present is eternity.

JOHANN WOLFGANG VON GOETHE

QUEEN NEFERTITI

Queen Nefertiti was the beautiful wife of the "heretic" Pharaoh Akhenaten, Egypt's first monotheistic ruler. She enjoyed considerable prestige at court, and early in Akhenaten's reign was even depicted in official paintings in poses traditionally reserved for the Pharaoh. They had six daughters, two of whom would later become queens, and images of their family show them to be loving and affectionate with one another. This masterpiece is one of the most beautiful and familiar images of a woman to survive from ancient times. Sculpted over 3,300 years ago, still it ranks among the world's greatest works of art.

. El Armana, Egypt; 1353–1335 BC; painted limestone and plaster; height 19 inches (48 cm).

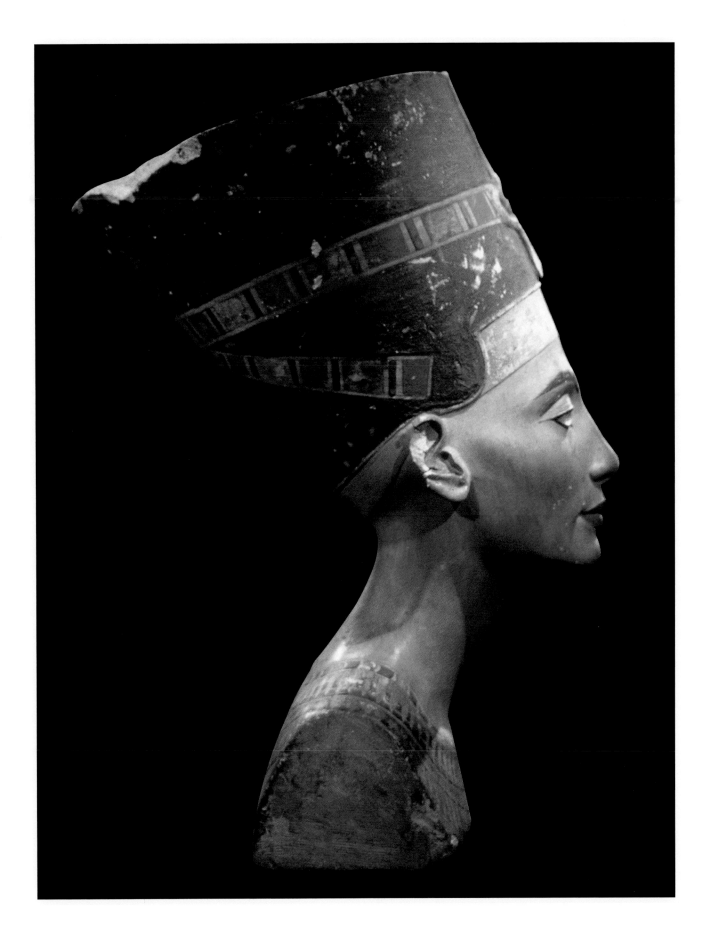

A billion stars go spinning through the night,
blazing high above your head.
But in you is the presence that
will be, when all the stars are dead.

<div align="right">RAINER MARIA RILKE</div>

Chinesco ceramics form a suborder of the Nayarit style (see pages 18 and 19), and are so limited in number, and of such outstanding aesthetic quality, that they may represent work from a single school. While Chinesco pottery was being made and placed in newly dug shaft tombs, the Teotihuacan, powerful neighbors to the east, were busy erecting their enormous Pyramid of the Sun. That structure, situated over a natural cave that was left open along one side, was built to celebrate the importance of the cave in the Teotihuacan creation myth. The cave was filled with ritualistic objects, and its ceiling was lowered in places to cause people to alternate between walking and crawling as they entered. That their leading deity was a goddess suggests the cave may have been symbolic of the womb. The large and hollow Chinesco figure opposite seems to delight in the child growing inside her.

. Western Mexico; 100 BC–250 AD; burnished ceramic; height 23.1 inches (37.8 cm).

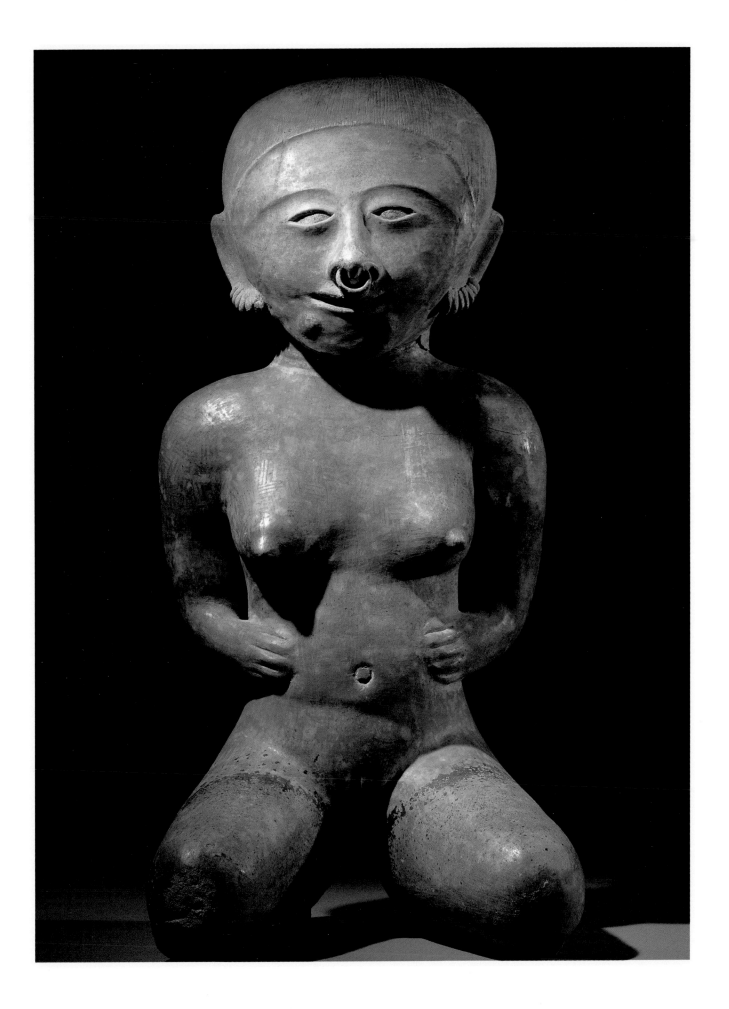

How do I love thee? Let me count the ways.
I love thee to the depth and breadth and height
My soul can reach.

ELIZABETH BARRETT BROWNING

BODY MASK

The Makonde, a major ethnic group from Tanzania in East Africa, celebrate two important rites of passage with elaborate dance ceremonies. After they reach puberty, the "Mapiko" is danced to initiate and welcome young women and men into the adult community; and the "Ngoma" is an instructional dance for young adults, to teach them about married life and their new responsibilities. The rare body mask opposite is one of the many beautifully made masks used in these sacred rites. It split at the top and was laced back together.

. Tanzania, Africa; twentieth century (?); height 20 inches (50.8 cm).

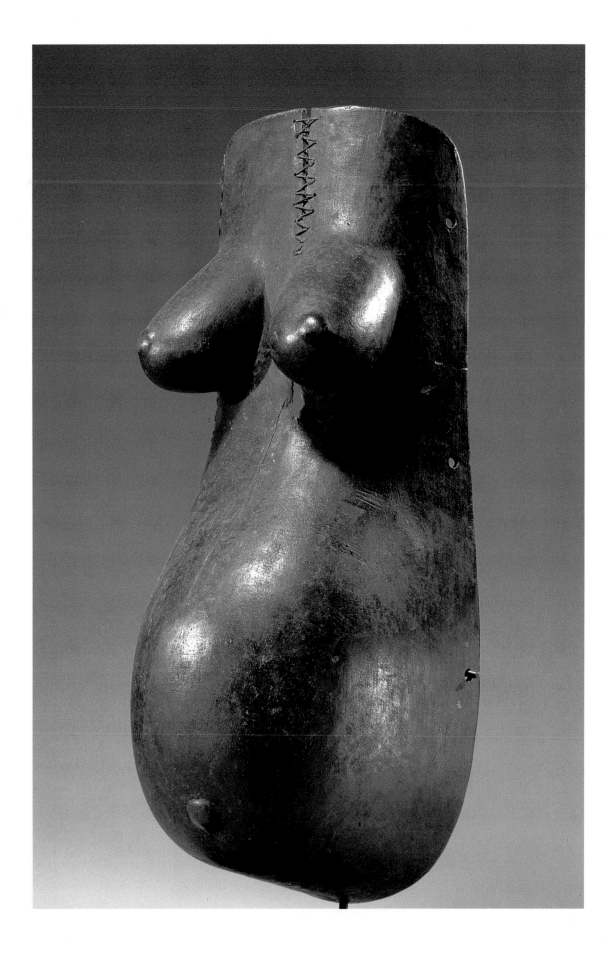

Before you were conceived
I wanted you
Before you were born
I loved you
Before you were here an hour
I would die for you
This is the miracle of life.

MAUREEN HAWKINS

SPIRIT MOTHER AND CHILD

This mother and child carving was made by a Baule woodworker from the Ivory Coast. The Baule believe that before they are born, they live in the spirit world, and often have intimate relationships with other spirits. A person's spirit lover may choose to stay near them during their lifetime on earth, and may become jealous or angry, and cause serious problems, if not treated with the proper respect. Figures like this one are carved to represent individual spirit lovers, and are flattered, caressed, and treated with great deference and affection.

. Africa; early twentieth century; wood, beads; height 20 inches (51 cm).

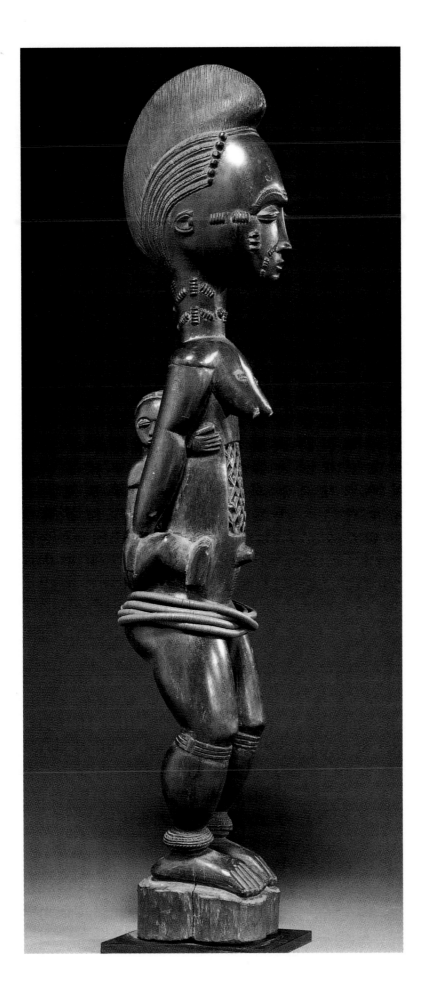

It's the support and care and love that you give yourself
that gives you the real strength to care for and love others.

OPRAH WINFREY

TWO LUBA WOMEN

The Luba are one of several major tribal kingdoms in Zaire. They emerged as a feudal state in the fourteenth century, just a few years before Europeans arrived looking for slaves. The slave trade was to take a terrible toll on Africa. At first some natives were willing to trade their enemies into slavery, but demand soon exceeded supply, and white slavers mounted devastating raids. It is estimated that from 1450 to 1850, 15 to 20 million women, men, and children were shipped to Europe and America as slaves. Many were young girls, who were sold as "breeders." This Luba ceremonial staff comes from a period after that horror had ended, when it was no longer necessary to live in hiding. These two beautiful young women seem to be mirror images of each other.

. Zaire, Africa; early twentieth century (?); height of these two figures approx. 7.75 inches (19.5 cm).

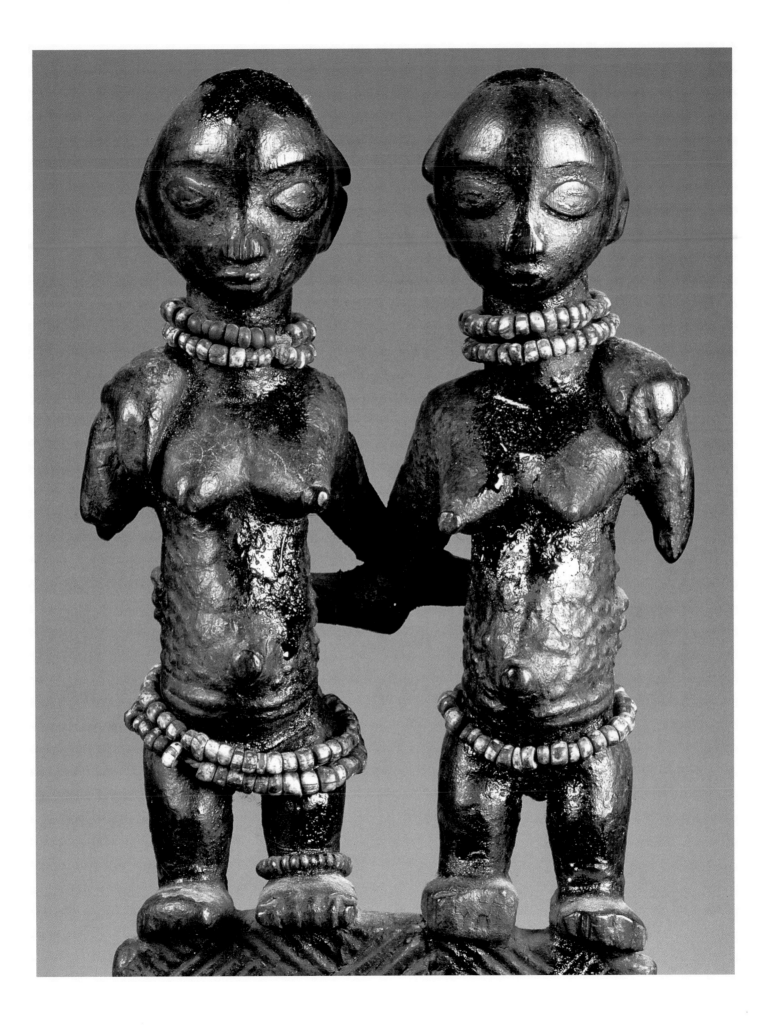

W hen in doubt, make a fool of yourself.
There is a microscopically thin line
between being brilliantly creative and
acting like the most gigantic idiot on earth.
So what the hell, leap.

<div align="right">CYNTHIA HEIMEL</div>

BAMANA HEADDRESS

The Bamana people live in Mali just south of the Sahara Desert. Numbering nearly two million, they occupy large villages, and are primarily farmers and craftspeople. Having developed a rigid caste system based on occupation, most Bamanas marry within their own caste. Blacksmiths are one of the highest castes. As "handlers of power," they are believed to be able to transmute the energy, called Nyama, that animates the universe into matter and back again. For them, every day begins with medi-tation and sacrifice to create a harmonious work environment. It is believed that a blacksmith's forge is so potent that a woman who joins the smith on it in sitting meditation will overcome infertility. This woman rider is protected from danger by her antelope, whose large ears will hear it coming, and whose speed will keep her out of its reach.

. Mali, Africa; twentieth century (?); iron; height 18.5 inches (47 cm).

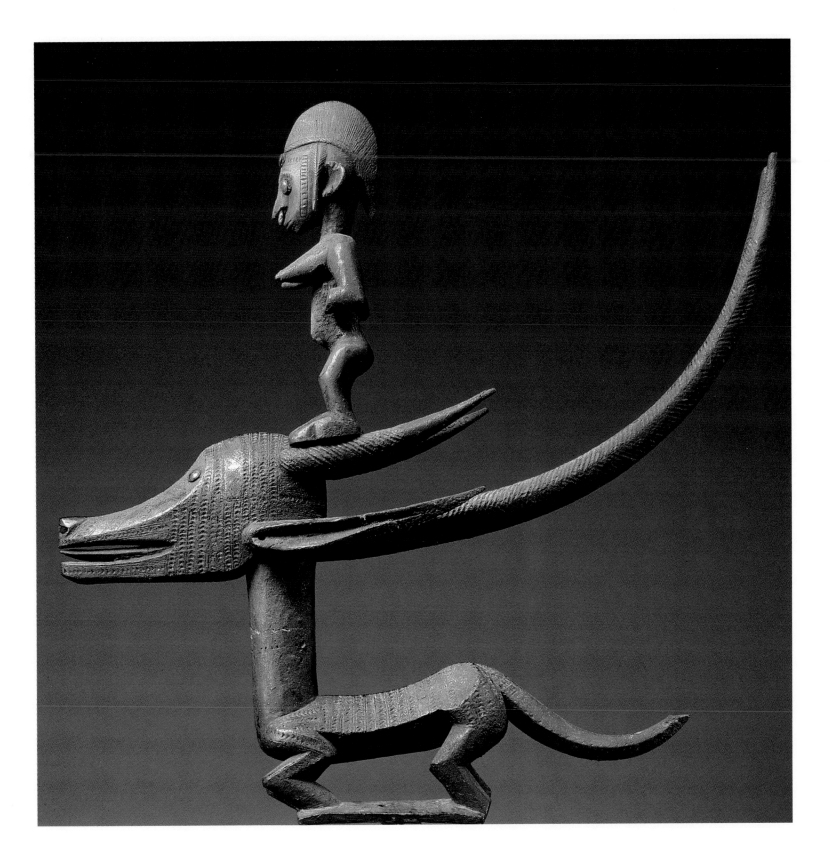

All laws which prevent women from occupying
such a station in society as her conscience shall dictate,
or which place her in a position inferior to that of man,
are contrary to the great precept of nature,
and therefore of no force or authority.

<div align="right">

ELIZABETH CADY STANTON
SUSAN B. ANTHONY
MATHILDA GAGE

</div>

GODDESS MINERVA (WAR)

Here is Roman Minerva, adapted from Greek Athena, in her persona as virgin warrior. She loved to do battle, and championed warriors and heroes. It was she who guided Perseus' arm when he cut off Medusa's head and she who protected Odysseus on his return from Troy. Even her birth was violent. According to myth, Zeus consumed his pregnant wife Metis to prevent their child from growing up to supplant him, as had been prophesied. To cure him of the terrible headache that resulted, Hephaestus hit him in the head with a bronze ax, and out jumped Athena, eyes flashing and javelin raised. Beautiful, wise, and brave, she immediately became her father's favorite. The city of Athens came under her personal protection.

. Herculaneum (buried by Mt Vesuvius eruption, 79 AD), Italy; first century BC; marble; height approx. 5 feet (152 cm).

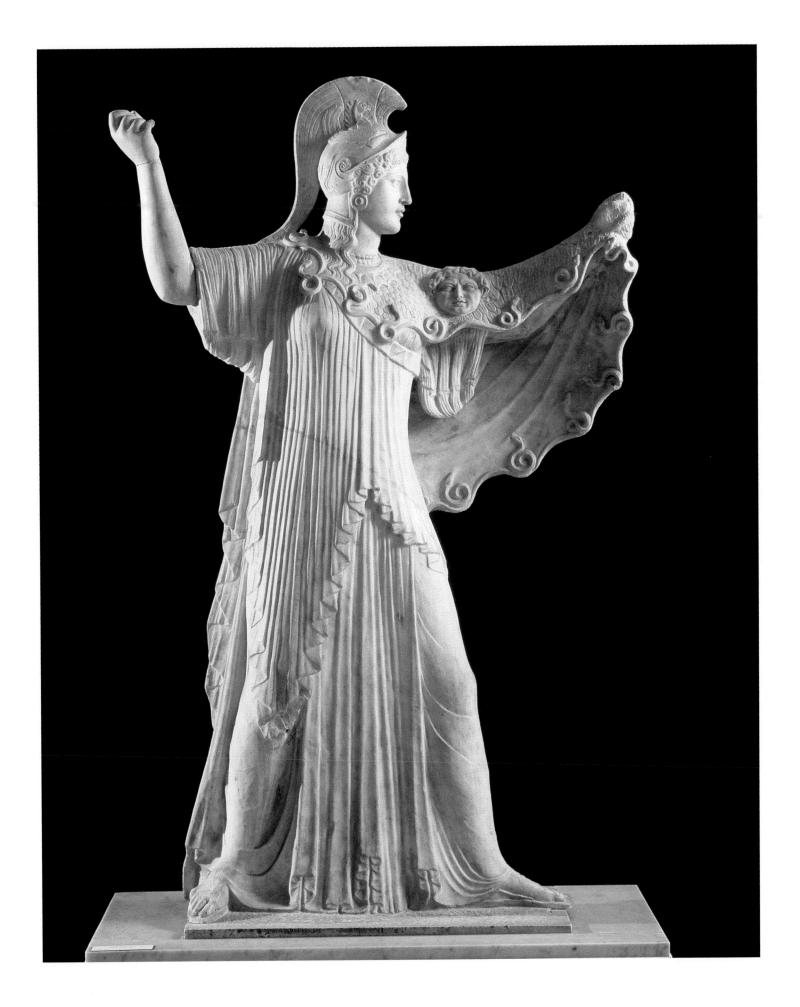

When you are old and gray and full of sleep,
And nodding by the fire, take down this book,
And slowly read, and dream of the soft look
Your eyes had once, and of their shadows deep;

How many loved your moments of glad grace,
And loved your beauty with love false or true
But one man loved the pilgrim soul in you,
And loved the sorrows of your changing face.

And bending down beside the glowing bars
Murmur, a little sadly, how love fled
And paced the mountains overhead
And hid his face among a crowd of stars.

WILLIAM BUTLER YEATS

GODDESS MINERVA (ARTS)

This is a Roman copy of a Greek statue of a goddess whose origin is Etruscan. To Etruscans she was Menrfa, goddess of the thunderbolt, depicted with wings and a screech owl in her hand. Etruscan women, extremely interested in prophecy, believed thunderbolts brought them information from the spirit world. Early on, Menrfa merged with Greek Athena, goddess of storms and lightning, to whom the screech owl was sacred. As Athena she showed several distinct natures: the patroness of arts and crafts, as well as the virgin warrior who delighted in battle. Here she is the former—kind, compassionate, and venerated by artists. Her creation of the olive made her all the more beloved by Mediterranean peoples.

. Italy; circa 100 BC; marble; height approx. 72 inches (183 cm).

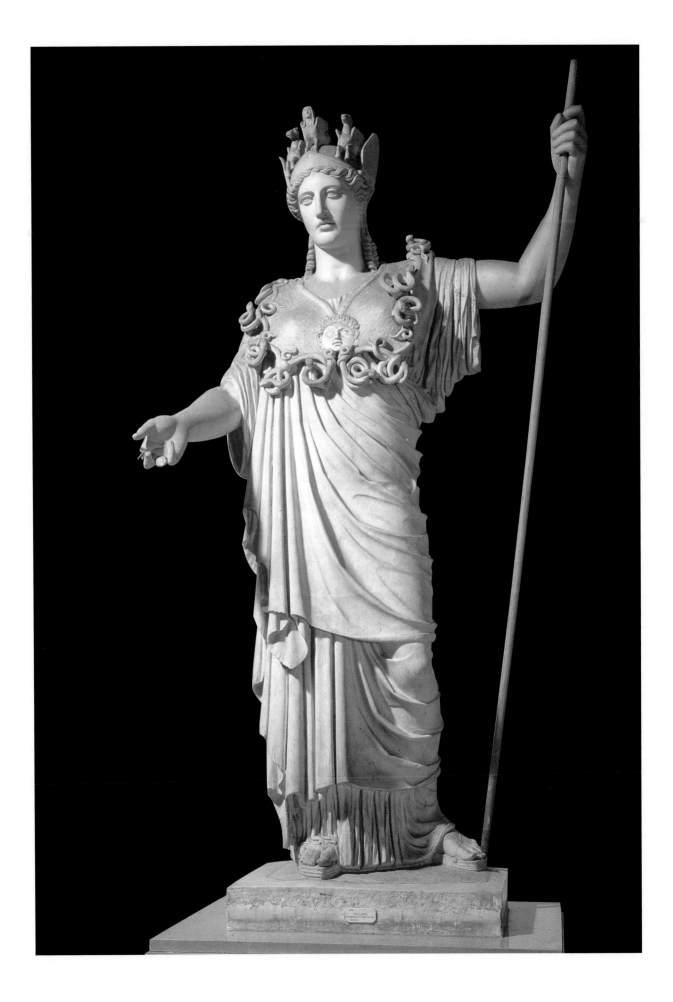

Although I conquer all the earth,

Yet for me there is only one city.

In that city there is for me only one house;

And in that house, one room only;

And in that room, a bed.

And one woman sleeps there,

The shining joy and jewel of all my kingdom.

<div align="center">ANONYMOUS, ANCIENT INDIA</div>

GODDESS PARVATI

Hindus believe in a demon who could be harmed by none save Shiva's offspring. Shiva, a holy man who wandered the mountains living in caves, had no interest in women, so when the demon threatened to destroy the world, the gods decided it was time to create a woman so beautiful that even Shiva couldn't resist her. That woman was Goddess Parvati, whose name means "she who lives in the mountains." She was exceptionally beautiful, but beauty alone was not enough to win Shiva's heart. Parvati was also ascetic and lived a life of renunciation, and that attracted Shiva. They were married in a beautiful ceremony (though stories tell that Parvati's mother fainted when she saw wild-looking Shiva for the first time). Their child did indeed slay the demon, and Parvati and Shiva created a life together that serves as an example of a marriage in which all parts are brought into harmonious balance.

. Indian; circa twelfth century; bronze; height 22 inches (55.9 cm).

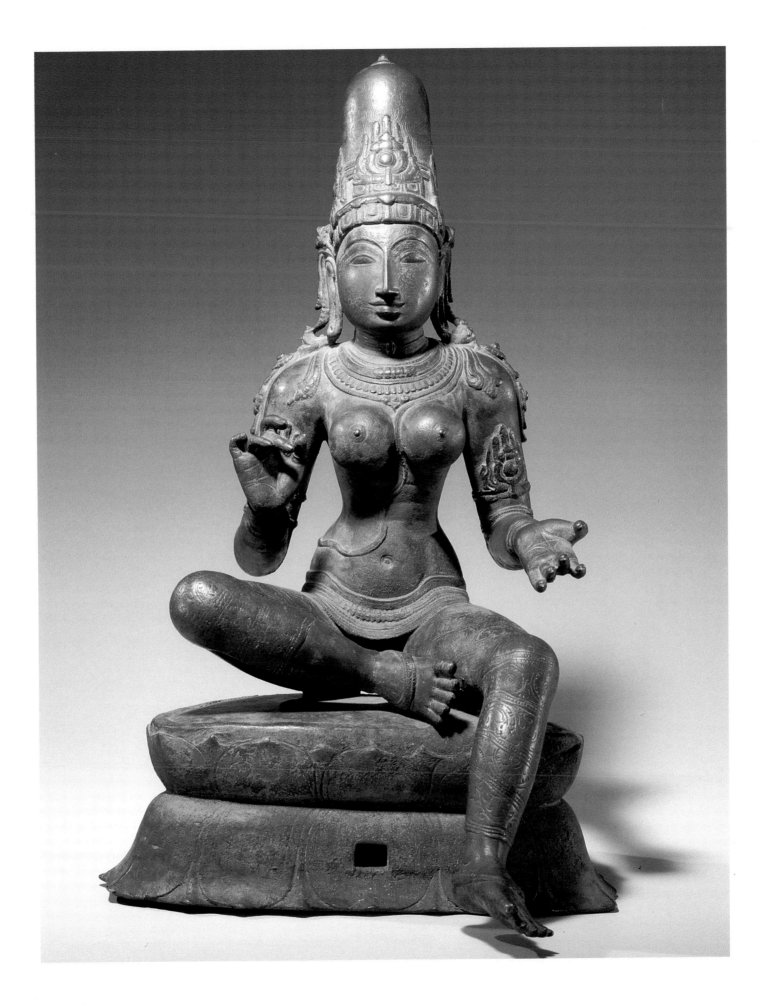

Are you a princess?
I said & she said I'm
much more than a princess
but you don't have
a name for it yet
here on earth.

BRIAN ANDREAS

GODDESS SARASVATI

Sarasvati first appears in the Vedas, India's oldest religious texts, as goddess of the Sarasvati River, which was said to flow from heaven. She symbolized purity, and had the power to cleanse, heal, and fertilize. Over time her nature changed, and she became the goddess of culture, poetry, music, and wisdom. She still retains some of her older personas, such as this—the goddess of rain, the life-giver, standing here on the side of a breezy road in Bali, as rain clouds fill the sky. The Balinese, who are all artists, whether it be singers, dancers, painters, sculptors, or weavers, adore her. There isn't a separate word for artist in Balinese. They are a gentle people who have woven the sacred into all aspects of their lives; Sarasvati is the perfect goddess for them. In this sculpture she holds a narrow book to symbolize learning, a lute for music, and a rosary for spiritual pursuits; her fourth hand is in a dance position.

. Bali, Indonesia; 1996; stone; height 5 feet (152.4 cm).

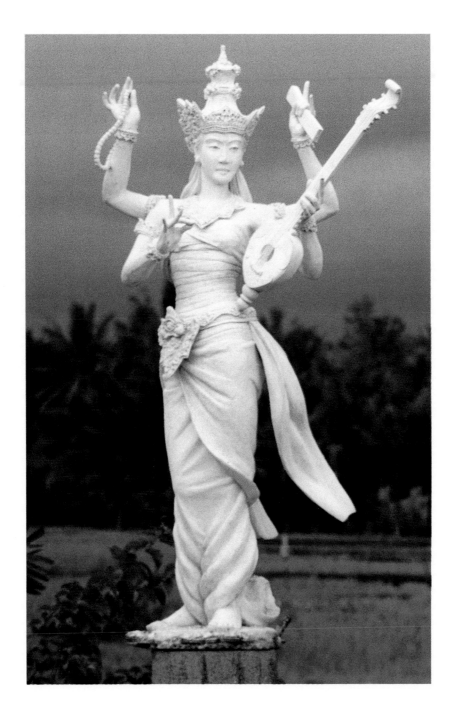

*P*eople who pursue their dreams
are the future.

BARBARA DEMETER

Durga is the most powerful and popular persona of the Goddess Parvati. When the Hindu gods were defeated by the fierce demon Mahisa, who could only be slain by a woman, they concentrated their energies into a brilliant beam of light, and out of it stepped Durga, their salvation. With weapons grasped in each of her many hands, Durga rode into battle on the back of a lion, and made short work of Mahisa. She went on to subdue many other "demons" who threatened to upset the cosmic balance. Interestingly, after she defeated them, they all wanted to marry her. The Goddess Durga is powerful and independent, but also warm and compassionate. Her many devotees believe that they can call on her during crises and receive personal attention.

. Nepal; nineteenth century (?); gilt-copper, semi-precious stones;
height 21 inches (53.3 cm).

88

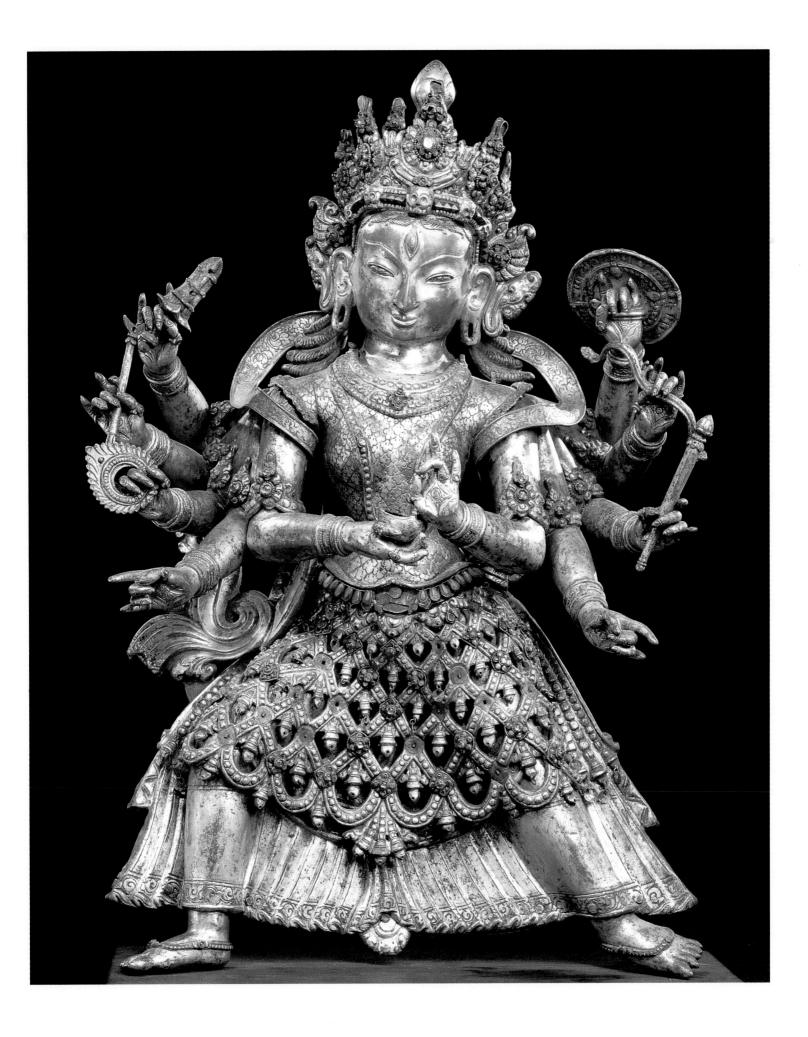

The true revolutionary
is guided by a great feeling of love.

CHE GUEVARA

THE LADY OF ELCHE

The Lady of Elche is an enigma. She was found in 1897 in La Alcudia, a small town near Elche on the east coast of Spain, but who she is and who made her are matters of considerable speculation. One theory suggests she is an Iberian princess or goddess dating from the fourth century BC. Other theories date her centuries later, and see Hellenistic, Roman, and even Celtic influences. Now a new theory calls her a forgery. Wherever she came from, she is wonderfully unique, her face expressing dignity, strength, and gentleness.

. Spain; date unknown; painted limestone; height 22 inches (56 cm).

90

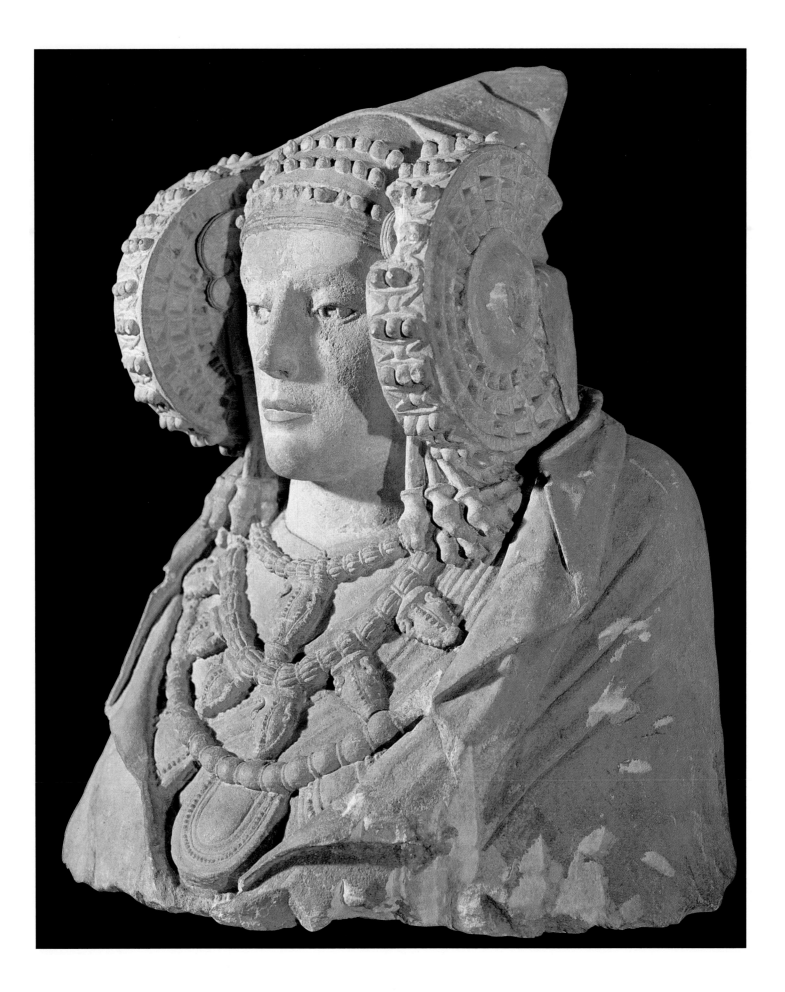

I am circling around God, around the ancient tower,
and I have been circling for a thousand years,
and I still don't know if I am a falcon, or a storm,
or a great song.

<div style="text-align: right">RAINER MARIA RILKE</div>

Winged Victory was found in 1863 on the island of Samothrace in the Aegean Sea. The French counsel Charles Champoiseau, an archaeologist, found it in 118 pieces scattered over a hilltop. He recognized its great value, and shipped the pieces to the Louvre in Paris. There they were assembled, and the statue, missing its arms and head, was put on view. This masterpiece of Hellenistic art commemorates a naval victory, and was meant to be mounted on the prow of a ship. Victory's robe looks wet from sea spray, as she leans forward into the wind.

. Greece; circa 200 BC; marble; height 6 feet 9.5 inches (2 m, 7 cm).

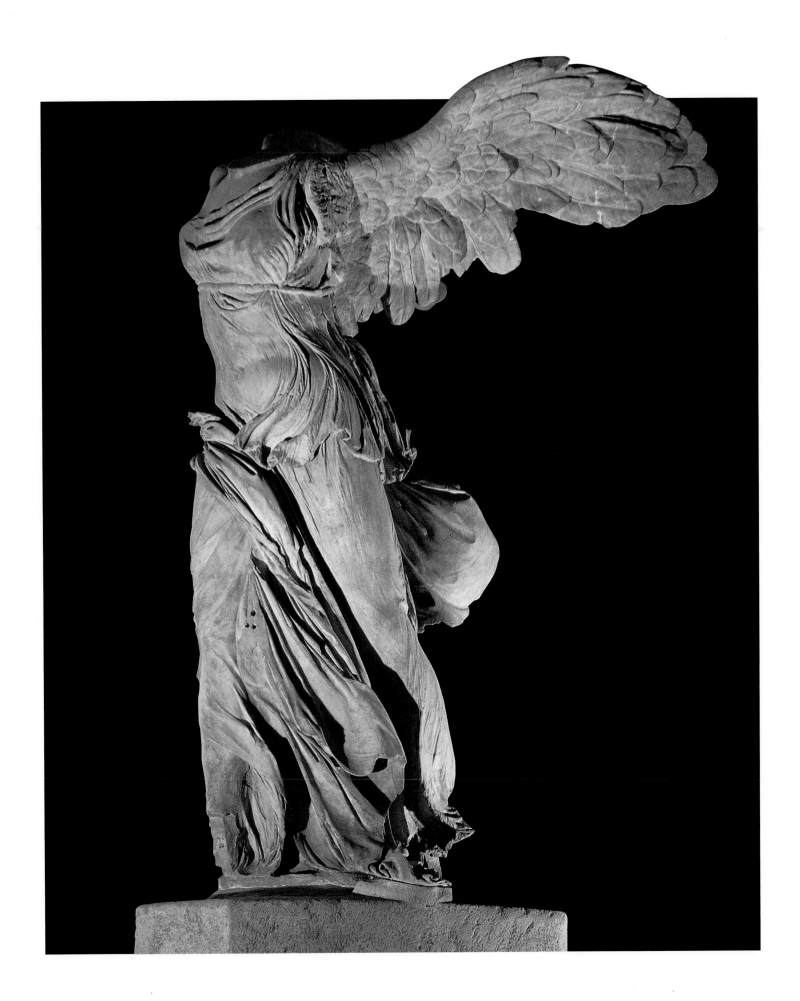

Time does not bring relief; you all have lied
Who told me time would ease me of my pain!
I miss him in the weeping of the rain;
I want him at the shrinking of the tide;
The old snows melt from every mountain-side,
And last year's leaves are smoke in every lane;
But last year's bitter loving must remain
Heaped on my heart, and my old thoughts abide.
There are a hundred places where I fear
To go,—so with his memory they brim.
And entering with relief some quiet place
Where never fell his foot or shone his face
I say, "There is no memory of him here!"
And so stand stricken, so remembering him.

EDNA ST. VINCENT MILLAY

SARAH BERNHARDT'S SCULPTURE

The actress Sarah Bernhardt (1844–1923) created this extraordinary sculpture. She was inspired by an old woman she had seen walking the beach in Brittany, sadly tossing bread crusts into the sea in memory of five sons and a grandson, who had all drowned. Sarah would sculpt for long hours, with great enthusiasm, sometimes wearing an elaborate candelabrum on her head so she could work into the night. She created over fifty sculptures, and had successful shows in Paris, London, and New York. About money she would say "When I have it, I spend it; and when I don't, I earn it." Generous and extravagant, she lived in a grand house in Paris, and entertained frequently. Once she had herself photographed in her coffin, where she sometimes slept, then sent the photographs to friends to remind them to live their lives fully.

. Sarah Bernhardt (French); 1876; bronze; height 29 inches (73.7 cm).

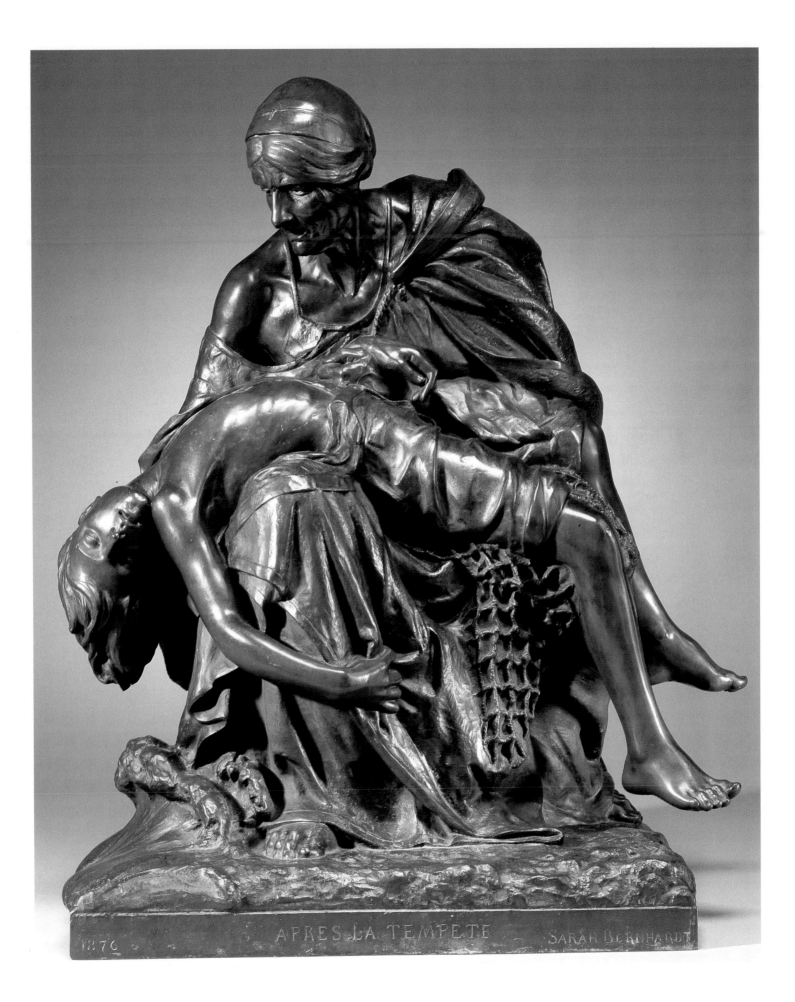

This thing we call 'failure' is not the falling down,
but the staying down.
You may have a fresh start at any moment you choose.

MARY PICKFORD

SARAH BERNHARDT

The Divine Sarah acted, painted, wrote novels and plays, cooked, designed costumes, and ran her own theater company; all "to keep from getting bored." The most famous actress of her day, she was admired for the emotional depth of her acting and for her golden voice. At fifty-six she played the lead in Hamlet, then followed it with stunning performances as Napoleon's nineteen-year-old son. Men fought duels for her attention. She floated over Paris in a hot air balloon sipping champagne. One Christmas she visited with the inmates in San Quentin prison. She publicly defended the falsely accused Alfred Dreyfus, and spoke out against antisemitism. Then, while on tour in South America in 1905, she seriously injured her leg; ten years later, when she was seventy, it had to be amputated. Not one to get mired in self-pity, Sarah continued to perform, and even had herself carried to the front lines during World War I, to recite for the adoring troops. Jean-Léon Gérôme gave Sarah this plaster sculpture he made of her.

. Jean-Léon Gérôme (French); 1895; plaster;
height 26.75 inches (67.9 cm).

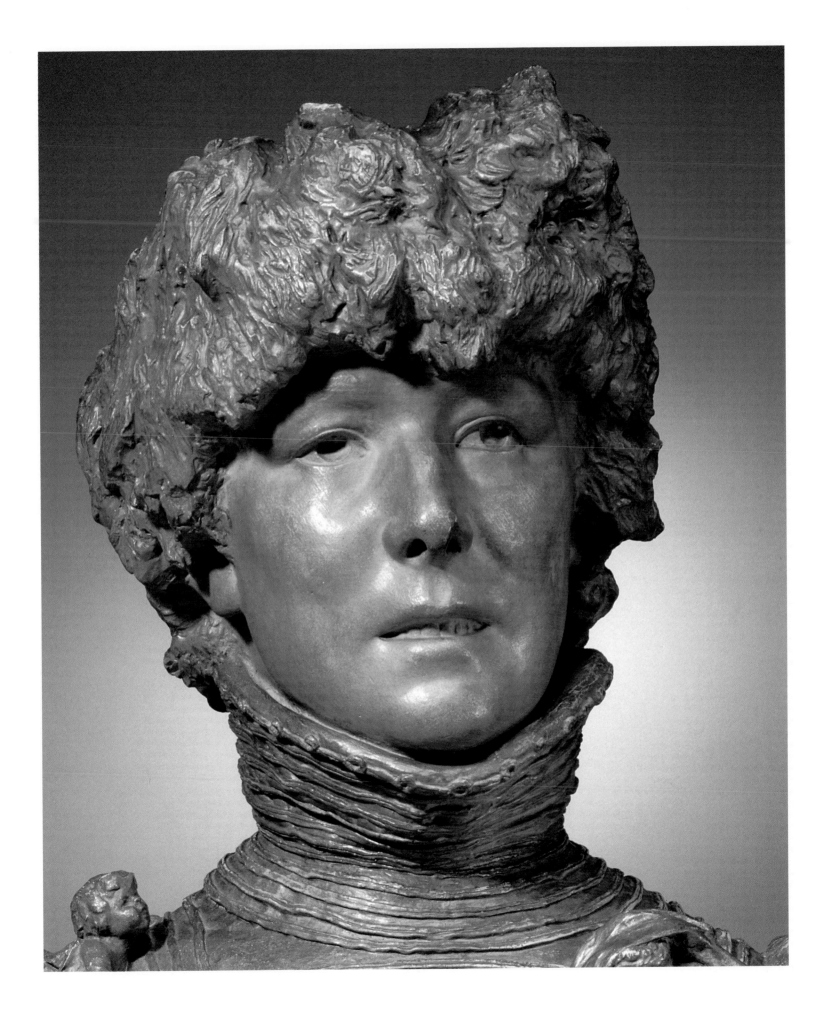

*The greater part of our happiness or misery
depends on our dispositions
and not our circumstances.*

<div align="center">MARTHA WASHINGTON</div>

APHRODITE

Though her own life was filled with drama, lovers, and children, Aphrodite still found time to aid those honorable souls who suffered in love. It was she who gave Meilanion the three golden apples, which he dropped one at a time to distract Atalanta while racing with her, thereby enabling him to win the race and her hand in marriage. And when the sculptor Pygmalion fell hopelessly in love with his own statue of a beautiful woman, it was Aphrodite who breathed life into the marble maiden just as he was sadly kissing it. But she also dealt harshly with those who denied love, or thought themselves more beautiful. She once caused Eos, goddess of the dawn and her rival for Ares' attention, to fall hopelessly in love with endless numbers of young men, to keep her occupied and out of the way.

. Italy; circa 350 BC; marble; height 9 inches (22.9 cm).

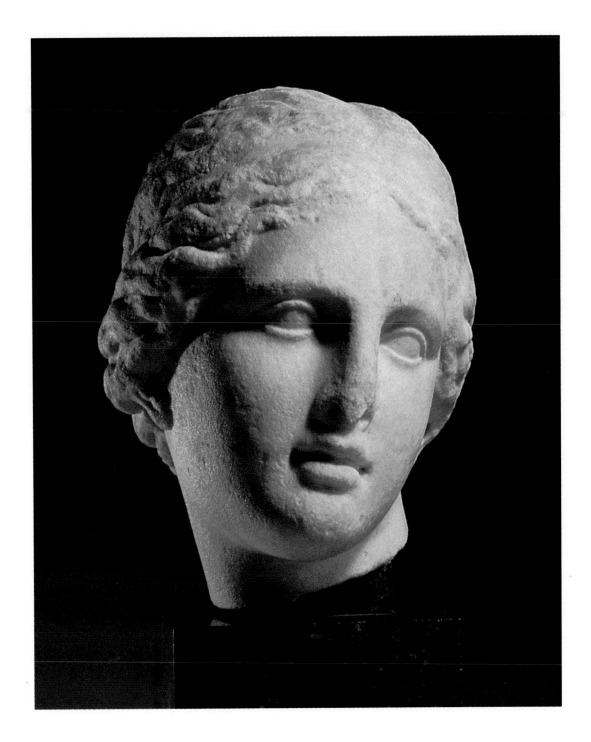

One is not born a woman,
one becomes one.

SIMONE DE BEAUVOIR

YOUNG WOMAN

This marble sculpture seems to freeze the moment when a girl becomes a young woman; she has the face of a child, but her body has flowered and entered womanhood. The tradition of carving a figure emerging from roughly hewn stone began with Michelangelo's four sculptures, the Captives (circa 1530). That approach is used here in a fresh and original way, to mark a rite of passage. The title, Convolvulus, given this piece by the sculptor, is a type of vine that twines its multiple stems together for support; the morning glory is an example.

. Alfred Boucher (French); circa 1896; marble; height 27 inches (68.6 cm).

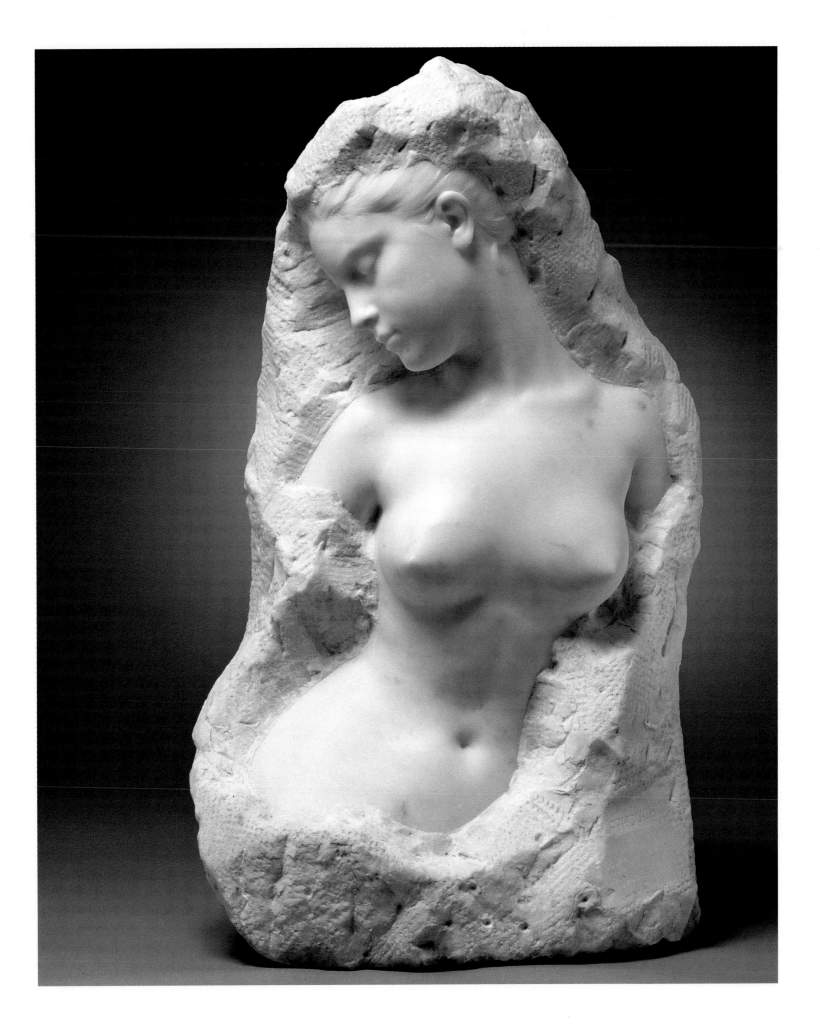

She took off her dress.
I my belt with the revolver.
She her four bodices.
Nor nard nor mother-o'-pearl
have skin so fine,
nor does glass with silver
shine with such brilliance.

FEDERICO GARCIA LORCA

APHRODITE BATHING

Aphrodite is the Greek goddess of love, beauty, and marriage (the Romans called her Venus). Born out of sea foam, she floated to shore at Crete on a shell. She was the most beautiful and seductive of all the goddesses, desired by men and gods alike, and she had many lovers. One was her adopted son Adonis, whom she had given to Persephone to raise. When Adonis grew to youthful manhood, both goddesses fell in love with him and neither would stand aside for the other. Zeus was asked to intercede, and decided that Adonis should spend part of the year with each. Aphrodite had children by many of her lovers, including Zeus; their son was winged Eros (Cupid to the Romans), the god of sexual love, who became his mother's companion.

. Italy; circa 300 BC; marble; height 17.7 inches (45 cm).

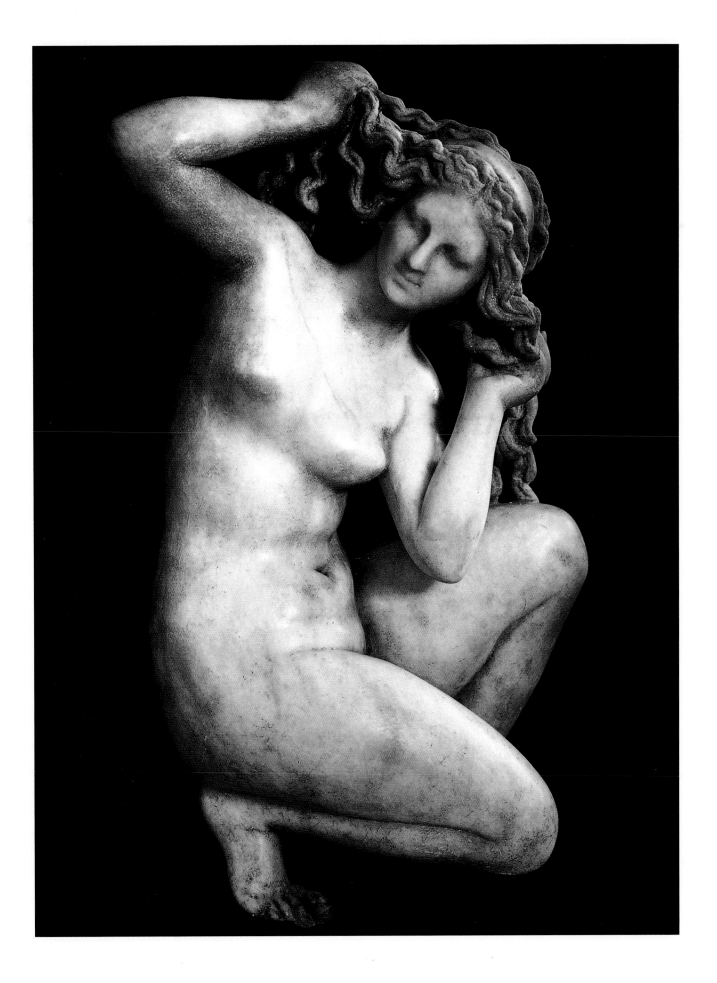

*Life is what happens to you
while you're busy making other plans.*

JOHN LENNON

Cleopatra VII was the last of the Ptolemaic rulers. When Alexander the Great died in 323 BC, nine years after conquering Egypt, his empire was divided and his general Ptolemy took Egypt. Three hundred years later, with Ptolemy's descendants still in power, seventeen-year-old Cleopatra inherited the throne, on the condition that she marry her older brother. Warned that he was about to have her killed, she fled, and returned with an army. Julius Caesar, just finishing a military action nearby, interviewed them both, and clearly favored Cleopatra. Her older brother died in the ensuing battle, so Cleopatra married her younger brother to strengthen her claim, became Caesar's lover, and soon bore him a son. Caesar died ten years later, and a struggle for control of the Roman Empire erupted between Octavian and Antony. Cleopatra sided with Antony, a choice that led to tragedy.

. Girolamo Masini (Italian); Cleopatra Seated on a Lion; 1875; height 48.5 inches (123 cm).

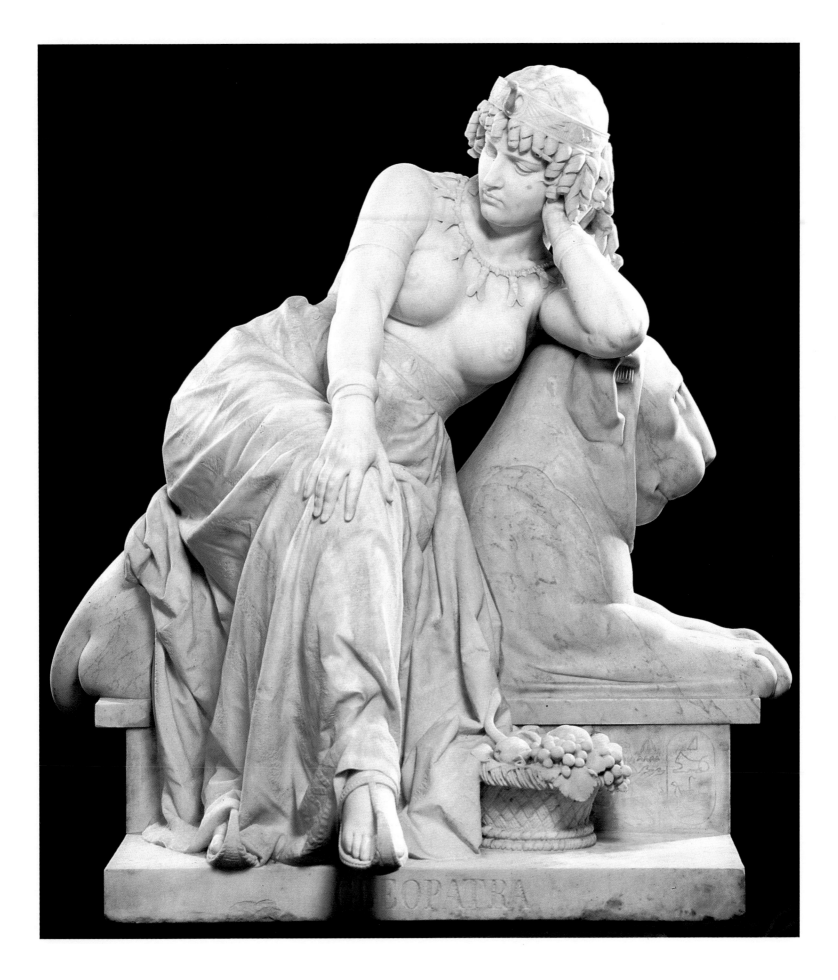

Make two homes for thyself, my daughter.
One actual home . . . and another spiritual home,
which thou art to carry with thee always.

<div align="right">SAINT CATHERINE OF SIENA</div>

This lovely sculpture is an example of Art Nouveau, a highly ornamental style most popular in Europe and the United States around 1900. It developed as a reaction against the classically imitative art of the nineteenth century and was strongly influenced by Celtic and Etruscan art. The Art Nouveau style is characterized by long, flowing, sinuous lines and organic forms, especially those found in nature (flowers, vines, insect wings, a woman's body). Barrias, who created this masterpiece of marble and bronze, made the woman appear as if she were emerging from a cocoon.

. Louis-Ernest Barrias (French); circa 1900; gilt bronze and marble; height 29 inches (73.7 cm).

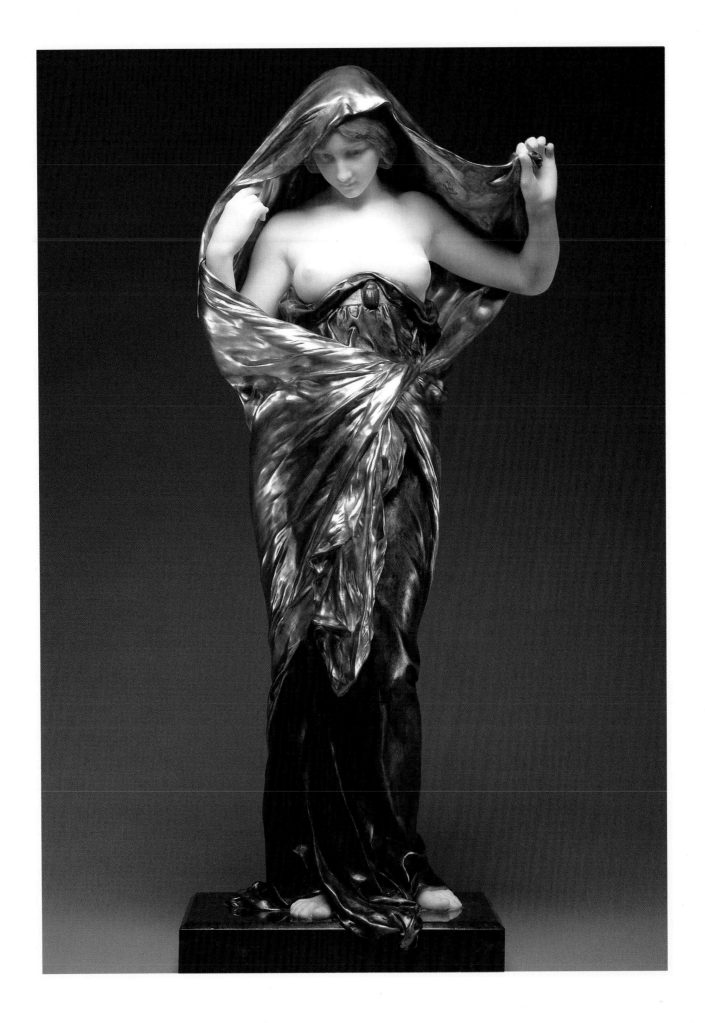

*When choosing between two evils,
I always like to try
the one I've never tried before.*

MAE WEST

SERPENTINA

This statue expresses the new confidence, strength, exuberance, and hope that many American women felt as the 1920s began. These attitudes came in part from the unrelenting efforts of women like Susan B. Anthony and Elizabeth Cady Stanton, cofounders of the women's suffrage (right to vote) movement. They began in the mid-1800s, leading antislavery and temperance (which sought protection for women and children from alcoholic husbands) movements. When, in 1872, black men were given the vote but women were still excluded, Susan B. Anthony and Elizabeth Cady Stanton organized the women's suffrage

movement. Thousands of other women took up the struggle, enduring humiliation, arrests, fines, beatings, imprisonment, hunger strikes, and devastating forced feedings (a tube was pushed through the nose to the stomach). Finally, in 1920, when many other countries were passing similar laws, the Nineteenth Amendment was ratified, guaranteeing American women the vote.

. Otto Poertzel (German); circa 1920; ivory and polychromed bronze; height 24 inches (61 cm).

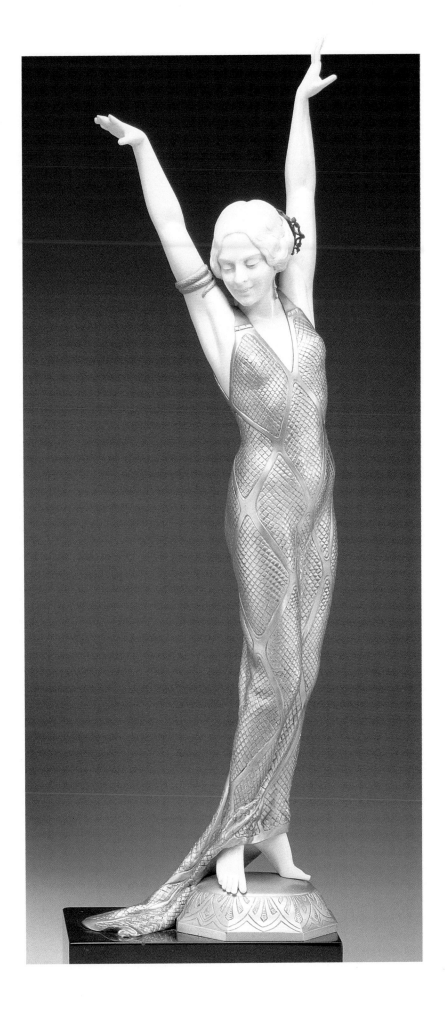

The most enlightened prayer isn't
'Dear God, send me someone wonderful,' but,
'Dear God, help me realize that
I am someone wonderful.'

MARIANNE WILLIAMSON

ART DECO DANCER

Throughout World War I and the influenza pandemic, which killed 21 million people (more than died in the war), women were struggling to gain their basic freedoms. Role models were crucial, and Helen Keller was an outstanding one. A childhood illness had taken her sight and hearing, and at Thomas Edison's suggestion, her parents hired Annie Sullivan, herself only partially recovered from blindness, to teach six-year-old Helen. The results were astonishing. Not only did Helen graduate *cum laude* from Radcliffe, but she wrote her autobiography in between her studies. She went on to write fourteen books, and to lecture tirelessly for women's rights, pacifism, and aid for the handicapped. The statue opposite is reminiscent of a butterfly that has just emerged from its cocoon, an apt image for women of the twentieth century.

. Demetre Chiparus (Romanian); gilt, silvered bronze, and ivory; 1925; height 26.5 inches (67.3 cm).

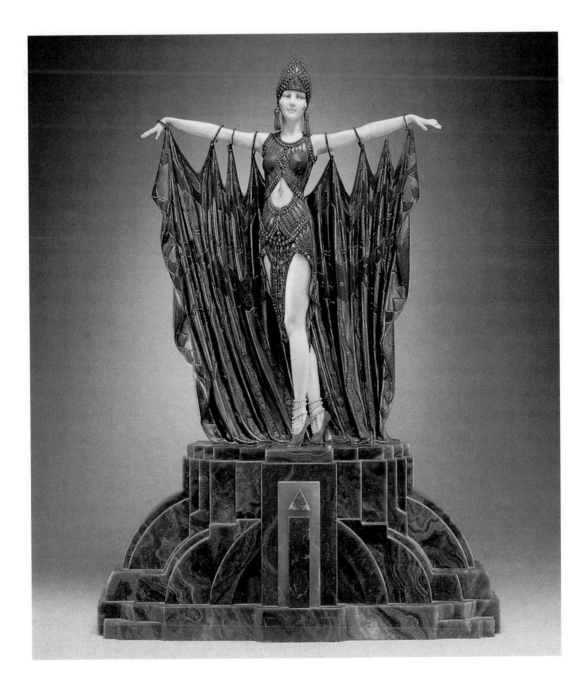

Your calling,
 a terrestrial visit.

You're smiling,
 and streams of light
 caress your beautiful form.

Oh. . . . my heart.
 A loss of breath
 as shadows flee.

<div align="right">JONATHAN MEADER</div>

PSYCHE AND CUPID

Psyche, which means "soul" in Greek, was so beautiful a mortal woman that even Venus (Greek Aphrodite) was jealous, and sent her son Cupid (Greek Eros) to punish her. Cupid was so startled by Psyche's beauty that he accidentally pierced himself with one of his arrows and fell in love with her. He came to her bed one night and explained that he was destined to be her husband, but that she must never attempt to see his face. She agreed; however, her evil sisters convinced her to look, and when she did one night, he awoke and fled. She then had to undertake and overcome the many terrible ordeals that Venus put in the way of her rejoining Cupid. When Psyche succeeded, both Venus and Cupid forgave her, and Zeus made her immortal so that she could join Cupid on Mount Olympus. Their marriage was cause for great celebration.

. G. Bergonzoli (Italian); circa 1890; marble; height 76 inches (1.93 m).

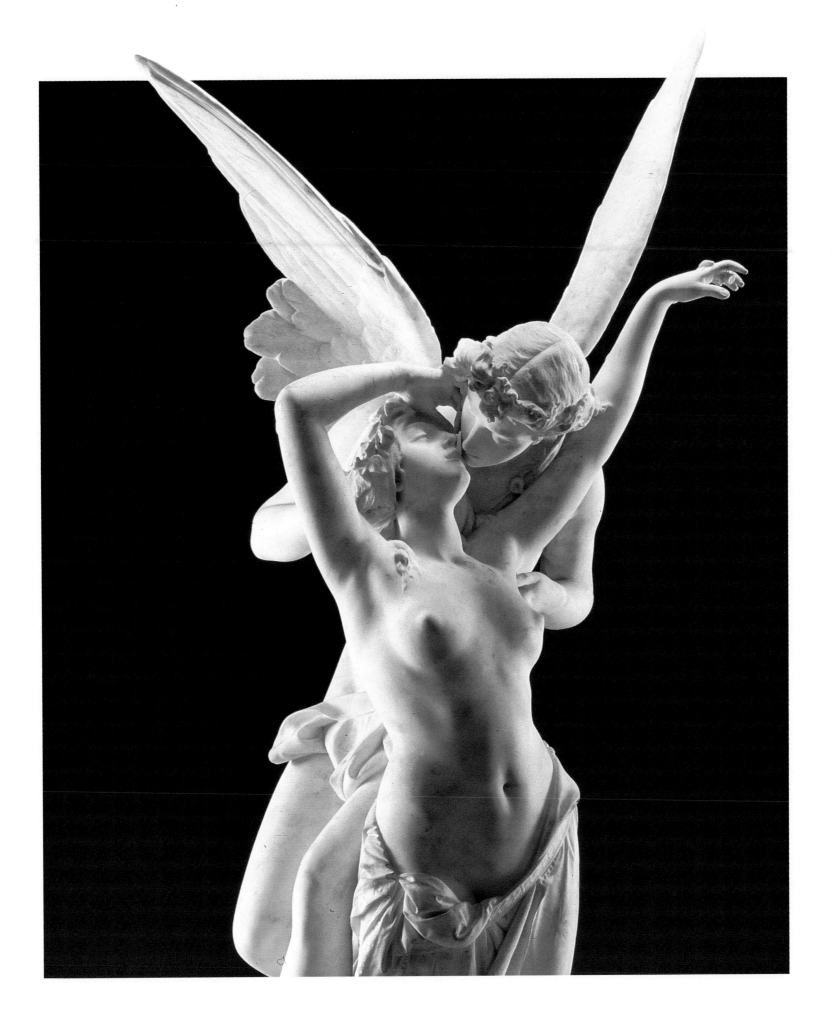

Life begets life. Energy creates energy.
It is by spending yourself that you become rich.

<div align="right">SARAH BERNHARDT</div>

YASHODA AND KRISHNA

Yashoda and her husband Nanda, leader of the cowherds, raised Krishna because it was not safe for him to live with his natural parents. Krishna, the eighth incarnation of the Hindu god Vishnu, was born to Devaki, sister of wicked King Kamsa. A prophecy foretold that Kamsa would be destroyed by one of Devaki's children, so he attempted to kill Krishna. To protect him from his uncle, his mother smuggled Krishna across the Yamuna River to the safety of the cowherd community, entrusting him to Yashoda, to love and care for him as tenderly as if he were her own, which she does in the copper sculpture opposite. The maidens of the community adored this god, and loved to dance with him in the moonlight.

. India; sixteenth century or later; copper; height 13 inches (33 cm).

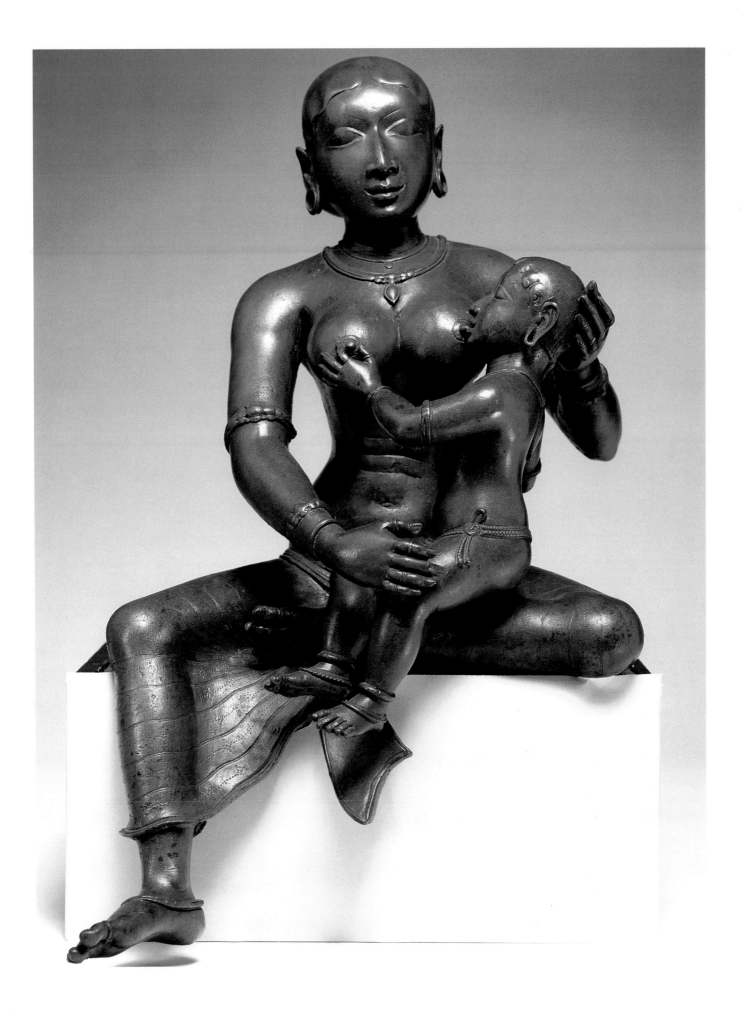

*In this immeasurable darkness, be the power
that rounds your senses in their magic ring,
the sense of their mysterious encounter.*

*And if the earthly no longer knows your name,
whisper to the silent earth: I'm flowing.
To the flashing water say: I am.*

<div align="right">RAINER MARIA RILKE</div>

GODDESS SYAMATARA

Syamatara is one of the 108 forms of Tara, known in Tibetan Buddhism as "the cheater of death." She is Green Tara, the original Tara, who embodies compassion. Many stories tell of spectacular rescues in which she snatches the faithful from the clutches of disaster and death. As a Bodhisattva, (an enlightened being who is ready to enter Nirvana), she chooses to continue being reborn here on earth until everyone has attained enlightenment. Here she is seated with her hands in *varada* (making a ring with her thumb and forefinger). Some of her gold has been worn away from the touch of thousands of devotees.

*.Tibet; seventeenth century; gilt-copper repoussé;
height 13.75 inches (34.9 cm).*

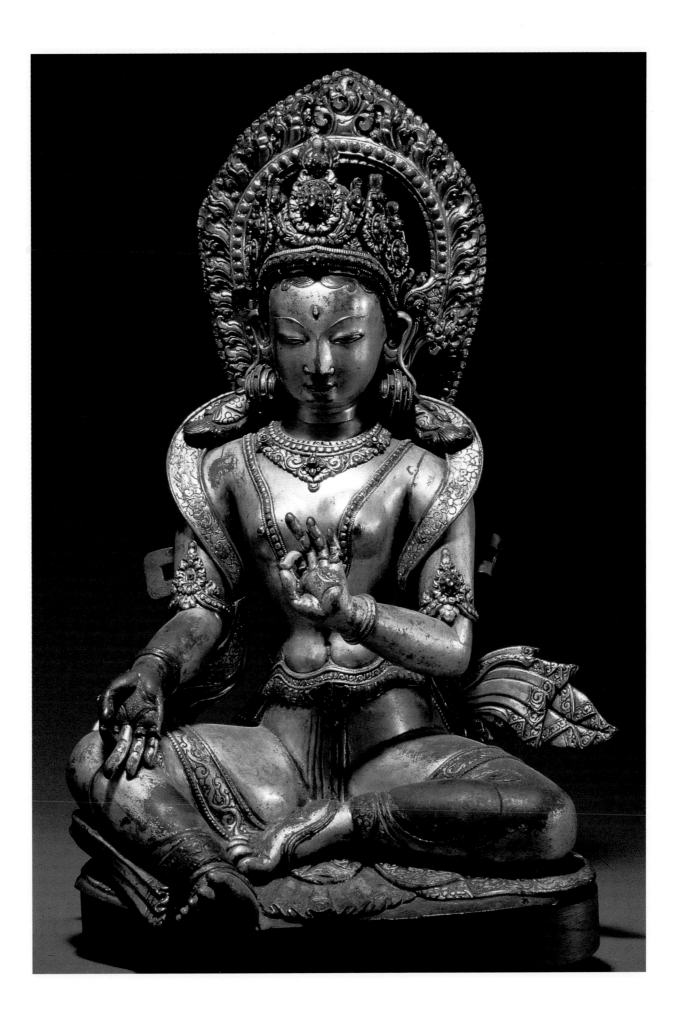

I think that wherever your journey takes you,
there are new gods waiting there
with divine patience—and laughter.

SUSAN WATKINS

Acknowledgments

I wish to thank the artists who created these marvelous sculptures, the photographers who photographed them, the people who wrote or spoke the quoted texts, and their publishers. I also thank everyone who gave me permission to reproduce these photographs and quotes, and those who encouraged me while I worked.

Thank you Isabel Allende for your beautiful foreword, Andrew Weil for your brilliant editing and proofreading, and Barbara Demeter for your support and kindness; thank you all for taking time to help when your own lives were already so full.

Bless you Mother Teresa for permitting your quote be used "for the Glory of God and the good of people." You said, "I am only a simple woman in Love with Jesus," and reached out and touched my heart.

Thank you Susanne Waugh and Sotheby's for your considerable assistance; without you this book would not have happened. Thank you Karen Meadows and Jane Heintzelman for all your support and encouragement; Jürgen Liepe for your superb photographs; Brian Andreas for your jewel-like stories; Paul Richard for your lasting friendship, and for believing; June Elliott for your faith and wry humor; and Hallie Iglehart Austen and Gwenn Jones for your generosity of spirit.

Thank you Riba Taylor for your excellent design work, Dave Hinds for your gentle strength, Heather Garnos for your invaluable assistance, Jo Ann Deck for your optimism, and Jen Page and Drew Hubal for your first rate computer assistance. Thank you

Oprah Winfrey, Lindsay Berents, Harpo, and Hyperion Press; Yoko Ono for your kindness; Lee Hubner at Sony for your help; thank you Kathe Quinn at Auction Catalog; Claudia Goldstein and Paul Evans at Art Resource; Mary Doherty at The Metropolitan Museum of Art; Elizabeth Barnett; Lynne Dal Poggetto; Susan Henry at the National Geographic Society; the Mill Valley Reference Librarians and School District personnel.

Many thanks to everyone at Celestial Arts and Ten Speed Press, especially Phil Wood, David Hinds, Heather Garnos, Veronica Randall, Kirsty Melville, Jo Ann Deck, Nancy Austin, Mary Ann Anderson, Leili Eghbal, Dennis Hayes, and Brook Barnum.

My sincere gratitude to family and friends for your support over the years: beautiful Hope, Lillian Wouters (my 103-year-old grandmother), Audrey Hope, Susan and Bob Tobias, Robin Meader, Alison and Roberto Pena, David and Masako Wouters, Kathleen Mellon, Nancy and Linda Cosgrove, Octavio Pérez, Kristen Westbrook, Kath Hay, Dianna Evans, Rose and Gary Wright, Deborah Richard, Don Elliott, Michael Katz, Judith Orloff, Stephan Minovich, Megan Holbrook, Leroy Montana, Richard Spiegel, Hayden and Stephan Schwartz, Sharon and Adrienne Wolpoff, Martha Palm, Mary Kennelly, Lucy Rosenbaum, Brian Turner, Valerie Soeters, Tish Webster, Laura Roland, Rita Abrams, Jim Null, Richard Jester, Ilene English, Judith Lyon, Naomi Lindstrom, Julie Hall, Sandy Montgomery, Terry Hermone, Jim Redpath, Mercer Mayer, Grigsby Hubbard, Suzanne Strisower, Stephen and Vicki Mitchell, and George and Judith Conley.

Credits

Photography Credits

Resources

Art Resource, 65 Bleecker Street (9th floor), New York, NY
 10012. Tel # (212) 505-8700; Fax (212) 420-9286.

Artist's Rights Society, 65 Bleecker Street (9th floor), New
 York, NY 10012. Tel # (212) 420-9160;
 Fax (212) 420-9286.

Auction Catalog Company (Kathe Quinn), 503 Live Oak
 Street, Miami, Arizona, 85539. Tel #: (520) 473-4088.

Brian Andreas: Story People, 216 West Water Street,
 PO Box 64, Decorah, Iowa 52101.
 Tel #: (800) 476-7178; (319) 382-8060;
 Fax: (319) 382-0263; http://www.storypeople.com

C M Dixon: Photo Resources; The Orchard, Marley Lane,
 Kingston, Canterbury, Kent CT4 6JH, England.
 Fax 44 1227 831135.

Jürgen Liepe, Photo Archive, Ahornallee 7, D–14050
 Berlin, Germany. Fax 030 306 13611.

National Geographic Society, Image Collection, 1145 17th
 Street, N.W., Washington, D.C., 20036.
 Tel #: (212) 857-7537; Fax (212) 429-5776.

Sotheby's, 1334 York Avenue, New York, New York, 10021.
 Tel #: (212) 606-7000.

Bibliography

Allen, Gay and Walter Rideout, James Robinson, editors. *American Poetry.* New York: Harper & Row, 1965.

Andreas, Brian. *Mostly True: Collected Stories & Drawings.* Berkeley: StoryPeople, 1994. Brian's books: *Mostly True, Still Mostly True, Going Somewhere Soon,* and *Strange Dreams.*

Arrowsmith, Alexandra and Thomas West, editors. *Two Lives: Georgia O'Keeffe & Alfred Stiglitz: A Conversation In Painting And Photographs.* New York: Callaway Editions, 1992.

Austen, Hallie Iglehart. *The Heart Of The Goddess: Art, Myth And Meditations Of The World's Sacred Feminine* Berkeley: Wingbow Press, 1990.

Bahn, Paul, editor. *100 Great Archaeological Discoveries.* New York: Barnes & Noble Inc., 1995.

Beauvoir, Simone de; translated and edited by H. M. Parshley. *The Second Sex.* New York: Alfred A. Knopf, 1953.

Bernhardt, Sarah. *The Memoirs Of Sarah Bernhardt.* Sandy Lesberg, editor. New York: Peebles Press, 1977.

Berrin, Kathleen and Esther Pasztory, editors. *Teotihuacan: Art From The City Of The Gods.* The Fine Arts Museum Of San Francisco: Thames and Hudson, 1993.

Bly, Robert, translator. *Selected Poems Of Rainer Maria Rilke.* New York: Harper & Row, 1981.

Branigan, Keith and Michael Vickers. *Hellas: The Civilizations Of Ancient Greece.* New York: McGraw-Hill, 1980.

Burenhult, Göran, editor. *People Of The Stone Age: Hunter-gatherers And Early Farmers.* Vol. 2, Landmark Series. HarperSanFrancisco: 1993.

Casson, Lionel. *Ancient Egypt. Great Ages Of Man: A History Of The World's Cultures.* New York: Time-Life Books, 1972.

Cavendish, Richard, editor. *Mythology: An Illustrated Encyclopedia.* New York: Rizzoli, 1980.

Clayton, Peter. *Chronicle Of The Pharaohs: The Reign-By-Reign Record Of The Rulers And Dynasties Of Ancient Egypt.* London: Thames and Hudson, 1994.

Cohen, David, editor. *The Circle Of Life: Rituals From The Human Family Album.* HarperSanFrancisco, 1991.

Dickinson, Mary B., editor. *The Wonders Of The Ancient World: National Geographic Atlas Of Archaeology.* Washington D.C.: National Geographic Society, 1994.

Fantham, Elaine and Helene Foley, Natalie Kampen, Sarah Pomeroy, and H. Shapiro. *Women In The Classical World.* New York/Oxford: Oxford University Press, 1994.

Garcia Lorca, Federico. *The Selected Poems Of Federico Garcia Lorca.* New York: New Directions, 1961.

Gimbutas, Marija. *The Civilization Of The Goddess; The World Of Old Europe.* HarperSanFrancisco, 1991.

Gimbutas, Marija. *The Language Of The Goddess.* HarperSanFrancisco, 1989.

Graves, Robert, introduction. *New Larousse Encyclopedia Of Mythology.* London: Prometheus Press, 1972.

Heimel, Cynthia. *If You Can't Live Without Me, Why Aren't You Dead Yet?* New York: HarperCollins, 1991.

Heimel, Cynthia. *Get Your Tongue Out Of My Mouth, I'm Kissing You Good-bye.* New York: Ballantine Booke, 1993.

Kinsley, David. *Hindu Goddesses, Visions of the Divine Feminine in the Hindu Religious Tradition.* Berkeley and Los Angeles: University of California Press, 1986.

Kopper, Phillip. *The Smithsonian Book Of North American Indians, Before The Coming Of The Europeans.* Washington D. C.: Smithsonian Books, 1986.

Lurker, Manfred. *The Gods And Symbols Of Ancient Egypt.* London: Thames and Hudson, 1980.

Marangou, Lila, editor. *Cycladic Culture: Naxos In The 3rd Millennium BC.* Athens: Nicholas P. Goulandris Foundation: Museum Of Cycladic Art, 1990.

Millay, Edna St. Vincent. *Collected Sonnets.* New York: Harper & Row, 1959.

Mitchell, Stephen, editor. *The Enlightened Heart, An Anthology Of Sacred Poetry.* New York: Harper & Row, Publishers, 1989.

Mitchell, Stephen, editor and translator. *The Selected Poetry Of Rainer Maria Rilke.* New York: Vintage International, a division of Random House, 1982.

Parrinder, Geoffery, editor. *Religions Of The World: From Primitive Beliefs To Modern Faiths.* New York: Grossett & Dunlap, 1971.

Peter, Laurence. *Peter's Quotations: Ideas For Our Time.* New York: William Morrow and Co., 1977.

Pringle, Heather. *In Search Of Ancient North America, An Archaeological Journey To Forgotten Cultures.* New York: John Wiley & Sons, Inc., 1996.

Quotable Women, A Collection Of Shared Thoughts. Philadelphia, Pennsylvania: Running Press: 1989.

Rilke, Rainer Maria. Translated by Robert Bly. *Selected Poetry Of Rainer Maria Rilke.* Vintage International: Random House, 1980.

Sotheby's Catalogs, 1334 York Avenue, New York, New York, 10021.

Torbrügge, Walter. *Prehistoric European Art.* New York: Harry N. Abrams, 1968.

Tyldesley, Joyce. *Hatchepsut, The Female Pharaoh.* New York: Viking/Penguin, 1996.

von Zabern, Philipp. *The Egyptian Museum Cairo: Official Catalogue.* Cairo: The Organization of Egyptian Antiquities, 1987. Excellent. Jürgen Liepe's photographs.

Watkins, Susan. *Dreaming Myself, Dreaming A Town.* New York: Kendall Enterprises, Inc.

Whitehouse, Ruth and John Wilkins. *The Making Of Civilization: History Discovered Through Archaeology.* New York: Alfred A. Knopf, 1986.

Wyse, Elizabeth and Barry Winkleman, editors. *Past Worlds: The Times Atlas Of Archaeology.* New Jersey: Hammond, 1988.

Yeats, William Butler. Edited by Richard J. Finneran. *The Poems Of W. B. Yeats: A New Edition.* New York: Macmillan, 1983.

Authors Index